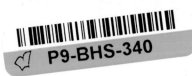

Joachim Wtewael

Mars and Venus
Surprised by Vulcan

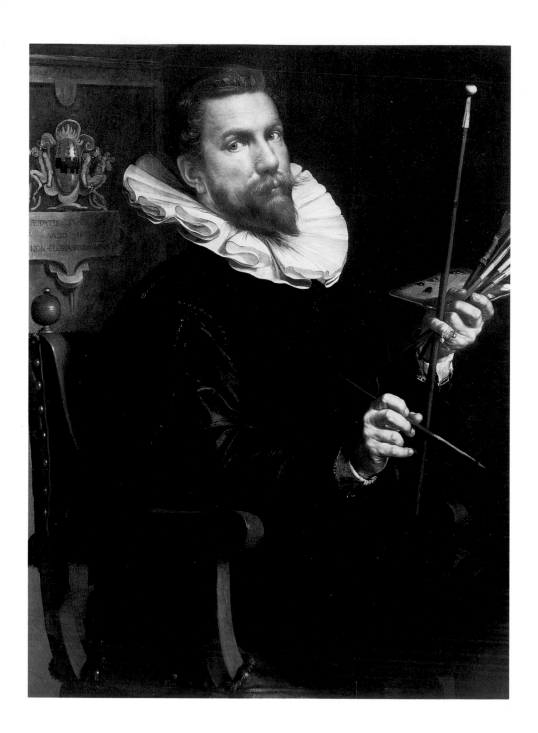

Joachim Wtewael

Mars and Venus
Surprised by Vulcan

Anne W. Lowenthal

**GETTY MUSEUM
STUDIES ON ART**

Malibu, California

Christopher Hudson, *Publisher*
Mark Greenberg, *Managing Editor*
Cynthia Newman Bohn, *Editor*
Amy Armstrong, *Production Coordinator*
Jeffrey Cohen, *Designer*

© 1995 **The J. Paul Getty Museum**
17985 Pacific Coast Highway
Malibu, California 90265-5799

Mailing address:
P.O. Box 2112
Santa Monica, California 90407-2112

**Library of Congress
Cataloging-in-Publication Data**

Lowenthal, Anne W.
 Joachim Wtewael : Mars and Venus
surprised by Vulcan / Anne W. Lowenthal.
 p. cm.
 (Getty Museum studies on art)
 Includes bibliographical references
 and index.
 ISBN 0-89236-304-5
 1. Wtewael, Joachim, 1566-1638. Mars and
Venus surprised by Vulcan. 2. Wtewael,
Joachim, 1566-1638—Criticism and inter-
pretation. 3. Mars (Roman deity)—Art.
4. Venus (Roman deity)—Art. 5. Vulcan
(Roman deity)—Art. I. J. Paul Getty
Museum. II. Title. III. Series.
 ND653. W77A72 1995
 759.9492-DC20 94-17632
 CIP

Cover:
Joachim Wtewael (Dutch, 1566–1638).
Mars and Venus Surprised by Vulcan,
circa 1606–1610 [detail]. Oil on copper,
20.25 x 15.5 cm (8 x 6⅛ in.).
Malibu, J. Paul Getty Museum (83.PC.274).

Frontispiece:
Joachim Wtewael. *Self-Portrait,* 1601.
Oil on panel, 98 x 74 cm (38½ x 29 in.). Utrecht,
Centraal Museum (2264).

All works of art are reproduced (and photographs
provided) courtesy of the owners unless otherwise
indicated.

Typography by G & S Typesetting, Inc.,
Austin, Texas
Printed by C & C Offset Printing Co., Ltd.,
Hong Kong

CONTENTS

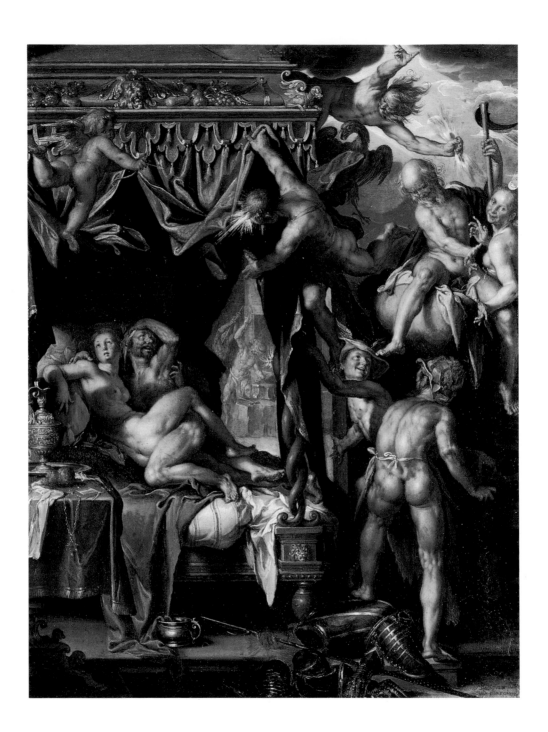

TELLING THE TALE

The Sun's loves we will relate. This god was first, 'tis said, to see the shame of Mars and Venus; this god sees all things first. Shocked at the sight, he revealed her sin to the goddess' husband, Vulcan, Juno's son, and where it was committed. Then Vulcan's mind reeled and the work upon which he was engaged fell from his hands. Straightway he fashioned a net of fine links of bronze, so thin that they would escape detection of the eye. Not the finest threads of wool would surpass that work; no, not the web which the spider lets down from the ceiling beam. He made the web in such a way that it would yield to the slightest touch, the least movement, and then he spread it deftly over the couch. Now when the goddess and her paramour had come thither, by the husband's art and by the net so cunningly prepared they were both caught and held fast in each other's arms. Straightway Vulcan, the Lemnian, opened wide the ivory doors and let in the other gods. There lay the two in chains, disgracefully, and some one of the merry gods prayed that he might be so disgraced. The gods laughed, and for a long time this story was the talk of heaven.

OVID *Metamorphoses* 4.171–189[1]

Mars and Venus Surprised by Vulcan, brilliant in color and dense with detail, powerfully evokes a miniature world [FIGURE I, FOLDOUT]. And what a world! An opulently furnished bedroom gives way beyond to a blacksmith's forge and above to a celestial ambiance. This setting is peopled not with ordinary mortals but with deities, the *dramatis personae* of Ovid's tale. The cynosure of the crowd—and ours as well—is the couple in bed, Mars and Venus, caught *in flagrante delicto.* The artist is Joachim Wtewael [FRONTISPIECE],[2] born in Utrecht, in the heart of the Netherlands, in 1566 and active there into the 1620s. His protean talents are reflected in the diverse styles and techniques of over one hundred extant paintings. In portraits and genre scenes, in stories from scripture

Figure 1
Joachim Wtewael
(Dutch, 1566–1638).
*Mars and Venus
Surprised by Vulcan,*
circa 1606–1610.
Oil on copper, 20.25 x
15.5 cm (8 x 6⅛ in.).
Malibu, J. Paul Getty
Museum (83.PC.274).

I

and myth, he explored a full range of subjects but was chiefly a history painter, who recreated the exploits of gods and goddesses, heroes and heroines. He did so on paper, canvas, panel, and copper, on both a miniature and a monumental scale. Today, as in his own time, Wtewael is especially admired for his astonishing small paintings on copper, of which the Getty Museum's *Mars and Venus Surprised by Vulcan* is an ideal example.[3]

The fascination of such paintings lies partly in Wtewael's virtuosic command of spatial illusionism on a small scale and his ability to suggest an infinite visual and dramatic complexity. The picture is only eight inches high, yet it holds the three different spaces mentioned above, eleven figures, and various engaging accouterments. The characters in Ovid's tale are readily recognized by their actions and attributes. The amorous couple is distracted. Venus, the goddess of love and beauty, looks up at her son Cupid, who flies directly above and regards us with a somewhat rueful expression. Naked Mars, having discarded his armor on the floor, twists to regard Apollo, the sun god, whose circuit around the earth has enabled him to see all. The blaze of light from Apollo's brow illuminates the adulterous pair as he pulls back the bed curtains. The bed's coverlet hangs down into the chamber pot and is thus twice sullied. Vulcan, Venus's cuckolded husband, wearing nothing but a flamboyant hat and a tattered leather apron, has just withdrawn the gossamer net he had fashioned to ensnare his wife and her lover. A red, winged hat identifies Mercury, the messenger of the gods, who laughingly displays the couple to his cohorts above. Old Saturn, holding his scythe astride a cloud, and Diana, adorned with a crescent moon on which is a tiny face, also delight in the lovers' predicament. Jupiter soars on high, thunderbolt in hand, to see what the fracas is all about.

The parted bed curtains reveal a vignette that provides a flashback to Vulcan's smithy [FIGURE 2]. Thus, Apollo not only exposes the illicit lovers but also calls our attention to this glimpse of the forge, where Vulcan hammers out the fine links at his anvil. Although muted in color, the scene is given importance by its central placement and theatrical presentation. Vulcan, the husband wronged, thus appears twice and is a leading character in the drama. His fellow immortals, whom he has summoned to witness the spectacle, are taking mis-

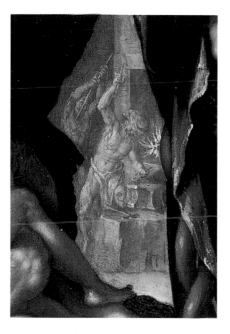

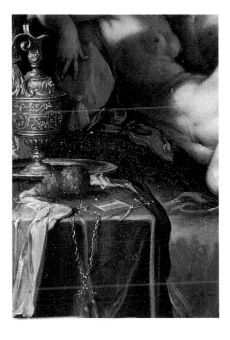

chievous pleasure in the scandal. Rather than raising the level of discourse to one of tragic betrayal or earnest moralizing, Wtewael lowers it to that of delicious gossip.

In keeping with this tone, like a director who stages Shakespeare in modern dress, he has added pointed references to daily life in the Netherlands of his own time. Most of the objects in the painting are either identical to ones that might have been used then, or they are fanciful elaborations. Among the former are the objects atop the square table, which is covered with a red velvet cloth fringed in gold [FIGURE 3]. This is evidently a washstand, provided with toilet articles and a magnificent silver-gilt ewer and basin. As opulent as these goldsmith's pieces seem, they were probably not imaginary, for comparable examples

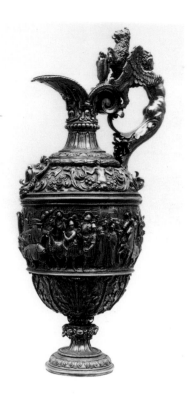

Figure 4
Ewer and basin, Italian or
Spanish, circa 1600–
1625. Silver-gilt, H
(ewer): 46.4 cm (18¼
in.); Diam (basin): 62.25
cm (24⅝ in.). New
York, Metropolitan
Museum of Art, Gift of
J. Pierpont Morgan, 1917
(17.190.2115 and
2116).

survive, such as those in the Metropolitan Museum of Art [FIGURE 4], which are
similar in size, richness, and design. The handle of the Metropolitan Museum's
ewer likewise ends in a scroll, and the body is ornamented with masks and bands
of strapwork. The Metropolitan Museum pieces are thought to be Italian or Span-
ish and to date from the early seventeenth century.[4] Such vessels could well have
made their way to the Netherlands. Indeed, Dutch *pronk* still lifes, showy dis-
plays like Willem Kalf's *Still Life with Ewer, Vessels, and a Pomegranate,* probably
painted in the 1640s [FIGURE 5], often include similar ones.[5] Wtewael's tabletop,
too, is virtually a still life, for the objects have been selected and arranged with an
eye to both form and function. Beside the ewer and basin are a sponge, a towel, a
small comb, and a pair of scissors. Today's barbers would feel entirely comfort-
able with the latter, for the design has remained unchanged over the centuries.[6]

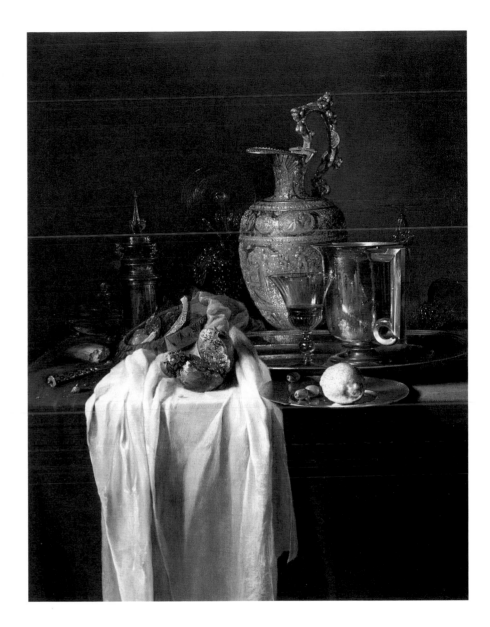

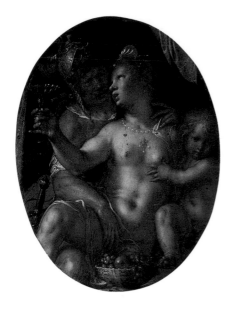

The jeweled pendant on a golden chain, hanging over the edge of the table and thus presented to our view, is like the one worn by Venus in another miniature by Wtewael, which depicts her with Mars and Cupid [FIGURE 6].[7] Such pendants were prized throughout Europe in the late sixteenth century, and many examples survive. Even Dutch women, who dressed conservatively by European standards, occasionally wore extravagant jewels like these.[8] The one in the Getty painting is very similar in design to an example that offers a particularly apt comparison [FIGURE 7]; the overall shape and the three pendant pearls accord with Wtewael's design, and the enameled figures at the center are none other than Venus and Cupid. Dating from around 1600, it is in the style of the French designers Jean Cousin the Younger and Ambroise Dubois.[9]

Wtewael has taken pains to depict Mars as a contemporary warrior, with field armor evidently modeled after specific pieces [FIGURE 8]. The small garniture comprises a breastplate with backplate and tasset attached, a pauldron, gauntlets, and a helmet, to protect the torso, thighs, shoulder, hands, and head, respectively. A red cloth lining for the breastplate helps to suggest wearability. In

style the suit is generally Western European, the narrow polished bands indicating French or Italian, rather than German, origin, and the peascod waist a date between about 1585 and 1595. The armor of Sir James Scudamore, who lived from 1558 to 1619 [FIGURE 9], is quite similar in style.[10] The photograph of Sir James's armor helps to make sense of that in the painting, which, in effect, lies

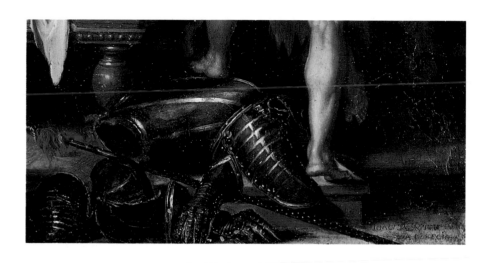

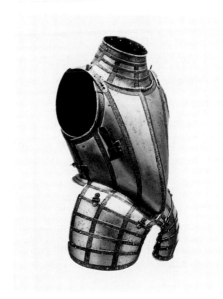

Figure 8
Joachim Wtewael. *Mars and Venus Surprised by Vulcan*, detail showing armor and signature.

Figure 9
Breastplate with taces and tassets from a suit of armor made for Sir James Scudamore, Greenwich, circa 1585–1595. Steel with etched and gilded bands. New York, Metropolitan Museum of Art, Hewitt Fund, 1911 (11.128.1).

on its back, having evidently been removed in a hurry and scattered along with the partisan, a processional weapon symbolic of rank. This one has two flukes and a red tassel.

The room is furnished with a bed and a chair so ornate that they hardly seem viable, yet both pieces reflect printed designs that inspired furniture makers of the time, adapted of course to the exigencies of construction. The twisting poster at the foot of the bed, as convoluted as the lovers, resembles a composite column in plate 23 of Gabriel Krammer's *Architectura,* first published in Prague in 1600 [FIGURE 10]. In the preface, Krammer presents himself as both a

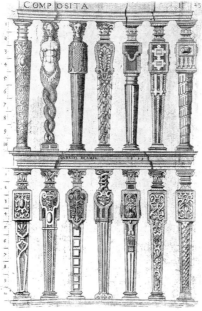

Figure 10
Composita II. Plate 23 [and detail] from Gabriel Krammer, *Architectura* (Prague, 1600). Avery Architectural and Fine Arts Library, Columbia University in the City of New York.

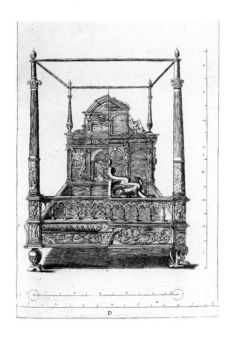

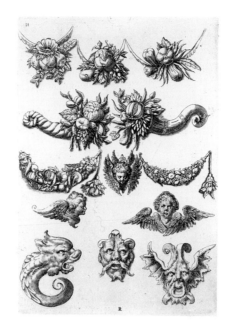

practical and a theoretical cabinetmaker, implicitly acknowledging both the pragmatism and the fantasy of his designs. The latter no doubt enhanced their appeal for the Hapsburg emperor, Rudolf II, to whom Krammer dedicated the first edition.[11] The design of the headboard of Wtewael's bed is similar to one in plate D of Crispijn van de Passe II's *Oficina arcularia* [FIGURE 11].[12] Although that area in the painting is deeply shadowed, it is possible to discern a classical frieze supported by Ionic pilasters flanking an arched central element. Unlike those of De Passe, Wtewael's bed posters support a solid, sculptural canopy hung with sumptuous draperies, but the baluster-shaped leg is consistent with De Passe's conception. Plate R from his *Oficina arcularia,* a page of ornamental designs [FIGURE 12], provides a pattern for such decorative elements as those on the canopy, not only the fruit swags but also the mask at the center. The winged dogs that form the base of the table beside the bed are also in the spirit of De Passe and another master of architectural design, Paul Vredeman de Vries.[13] That all of these ideas were put to use is confirmed by an actual Flemish bedstead,

Figure 11
Design for a bed. Plate D from Crispijn van de Passe II, *Oficina arcularia* (Amsterdam, 1642). New York, Metropolitan Museum of Art, Harris Brisbane Dick Fund, 1923.

Figure 12
Ornamental designs. Plate R from Crispijn van de Passe II, *Oficina arcularia* (Amsterdam, 1642). New York, Metropolitan Museum of Art, Harris Brisbane Dick Fund, 1923.

9

dated 1626, of carved oak inlaid with marquetry of colored woods [FIGURE 13]. The design of the posters and headboard reflects the ideas of Krammer as well as De Passe and De Vries.[14]

In the shadows at right, beside Vulcan, is a chair with an elaborately carved and gilded wooden frame supporting a red velvet seat and two bands that form the back. Again we can find a parallel, if not a source, for Wtewael's conception, in a drawing by the Swiss-German artist Peter Flötner, a master designer of furniture and metalwork and a practising goldsmith. His drawing for a ceremonial chair, probably from around 1528 [FIGURE 14], has all the flamboyant sculptural vigor of the one in the painting.[15] Wtewael's chair could have been inspired either by designs like Flötner's or by actual examples in that manner.

With a precise technique that fully exploits the potential of oil pigment on a copper support, Wtewael encourages intense scrutiny of his characters and furnishings. The rigidity, smoothness, color, and metallic sheen of copper all contribute to the visual effect of the picture. It is, of course, pos-

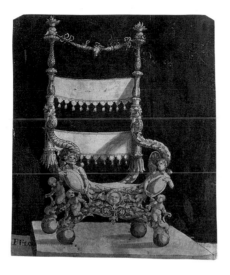

sible to paint freely on copper, as we know from several small portraits by Frans Hals, but the properties of this metal make it particularly well suited to a more meticulous technique. The paint surface forms a delicate low relief that can be appreciated in a raking light. Since oil pigment is semi-opaque, the light reflected from the copper shines through the paint layers, contributing to the picture's tonality. Painting in oil on copper had grown popular in Italy by the end of the sixteenth century, and Wtewael may well have become acquainted with it there in the 1580s.[16] Most of his small mythological scenes are rendered in this refined medium.

Since copper expands and contracts much less than panel and canvas in response to changes of temperature and humidity, the paint surface of the Getty picture has not suffered from the stresses that accompany such changes and is thus intact, without craquelure. Nor has the surface suffered from abrasion,

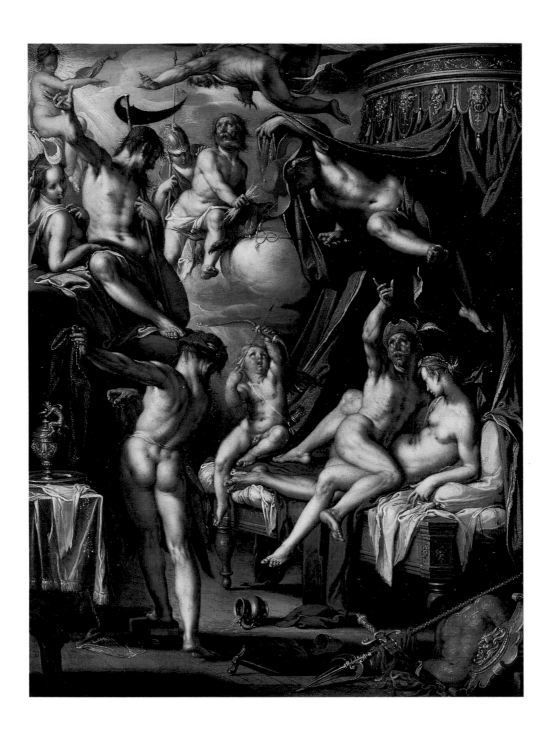

perhaps because it has led a sheltered life, as we shall see. This painting, then, looks today much as it did when first completed.[17]

Wtewael had depicted the story of Mars, Venus, and Vulcan at least twice before he painted the Getty picture. Another painting of the subject, dated 1601, is in the Mauritshuis in The Hague [FIGURE 15].[18] Again we encounter the familiar cast of characters: Mars and Venus are caught making love, as Vulcan triumphantly holds the fine net. Sitting on the foot of the bed, Cupid takes aim at Mercury, who in Homer's earlier account indeed wished he, too, could sleep beside Venus (*Odyssey* 8.337). Here, Mercury, not Apollo, draws back the bed curtains to reveal the lovers. Apollo, in the upper left corner, merely provides musical accompaniment. Diana, Saturn, Minerva, Jupiter, and another bearded god, perhaps Neptune, complete the Olympian company, which reacts rather soberly to the event. As in the Getty picture, the furnishings of the room are from Wtewael's time. The canopy of the bed is decorated with masks that recall plate R of De Passe's *Oficina arcularia* [FIGURE 12], and on the table there are again a towel, an elaborate ewer, its handle now formed by a satyr, and Venus's jeweled pendant. The chamber pot beside the bed has been upset and spills its contents. Vulcan's hammer and Mars's armor, sword, shield, and partisan lie on the floor at right.

Just beside these tools and weapons is a pair of bright red slippers, which in northern European folklore symbolize the power of women.[19] The juxtaposition signals the interplay between masculine and feminine forces that reverberates throughout both pictures, even among the witnesses in the clouds. Although Homer reported that the goddesses did not behold the scandal, out of modesty (*Odyssey* 8.324), Wtewael includes Minerva (in the Hague painting) and the chaste Diana among the immortals.

In both paintings, the furnishings of Venus's boudoir are plausible features of a luxurious seventeenth-century bedroom. The interior of the *burgerlijk* Dutch household that Adriaen van de Venne depicted in plate 10 of Johan de Brune's *Emblemata of zinne-werck,* published in Amsterdam in 1624 [FIGURE 16], although more modest, contains essentially the same furnishings, even down to the chamber pot beside the bed. But there, of course, we see no adulterous love

affair but a family, the weary mother slumbering away, the father walking a squalling baby. The accompanying poem, headed "Cry, in need, for heaven's feed" reveals the significance of the image:

> What unrest and racket, what worry, what trouble, what belching!
> The babe that wails and shrieks to lie beside the breast.
> The mother is tucked away; the father sings and sooths
> And paces o'er the floor, so that the child might rest.
> Whene'er we, too, at night, with thirsting spirit toss
> God suckles us with his word, and soon we feel we're blessed.
> He takes us in his hand and sings a cheerful song,
> The life of the deceased, the death of all distress.[20]

De Brune embeds a moral message in an ordinary scene, a device employed in most Dutch emblem books, which constituted one of the most popular literary forms of the seventeenth century. In such books, an image, often taken from daily life, is typically accompanied by an epigram and a text, here a poem that develops a spiritual lesson from the immediate situation. Didacticism pervaded emblematic literature, exemplifying a Dutch tendency to seek the universal in the particular, a higher principle in the quotidian.[21] De Brune's choice of a down-to-earth depiction of family life as a metaphor for both spiritual malaise and comfort was an ideal one for his *burgerlijk* readers. Ennobling everyday, or everynight, discomforts and irritations, he presented the stable, morally responsible family as the elemental building block of Dutch society.[22]

It is easy enough to see how De Brune's image of long-suffering parents endorses Dutch middle-class values. But how do we account for Wtewael's adulterous lovers, who flagrantly violate the very principles that society held so dear? Let us return to the painting in an effort to discover some clues. On the primary level, *Mars and Venus Surprised by Vulcan* illustrates the ancient story quoted at the outset, a story we can assume the literate Dutch knew through both visual and literary sources. But reverence for the classics cannot fully enlighten us about Wtewael's choice or his patrons' reception of this particular subject. The narrative, of course, provided him with an intrinsically compelling episode. He realized it with a psychological veracity and subtle inflection that invite imaginative interpretation. Mars and Venus have been caught coupled and embarrassed by the derisive laughter of their fellow immortals, yet Venus seems nonchalant and Mars is clearly amused. He is evidently oblivious of Vulcan, who has won the day through craft and craftiness. A vigorous, muscular blacksmith, god of fire whose power he could tame, Vulcan dominates his rival by stepping on the breastplate of Mars's armor as if on his fallen body. In staging this scene, Wtewael creates rather than resolves dramatic tensions. He walks a fine line, keeping in play the conflicting elements of eros and retribution, embarrassment and sang-froid, humor and outrage, vice and righteousness.

He sustains that tension in his choice of props, especially the group of things on the washstand. Although he places them seemingly casually at the

very periphery of the composition, their proximity to the eye-catching couple imbues them with importance. On the practical narrative level, the ewer and basin, comb, sponge, and towel make perfect sense as Venus's toilet articles. These objects also, however, carry connotations of grooming and cleansing in emblem books and the Bible. For example, the comb on the table is exactly like the one featured in Roemer Visscher's *Sinnepoppen,* published in Amsterdam in 1614 [FIGURE 17], with the epigram "It cleans and it beautifies," cleanliness presumably being the basis for beautification. Similarly, the silver-gilt ewer and basin, precious though they may be, have the humble function of holding cleansing waters. An emblem in yet another book, which shows water from a ewer being poured over clasped hands that emerge from clouds, develops that function into a symbol of spiritual purification,[23] a theme that has ample precedent, including such passages from Psalms as "I will wash mine hands in innocency: so will I compass thine altar, O Lord" (26:6). The scissors, however, introduce another idea, that of discrimination, since their sharp blades separate the retained from the discarded, by extension good from bad, virtue from vice.[24] Shears are also the

Figure 17
"Purgat et ornat."
Illustration from Roemer Visscher, *Sinnepoppen* (Amsterdam, 1614). Cambridge, Houghton Library, Harvard University.

attribute of Atropos, the Fate who cuts the thread of life, which introduces the theme of *vanitas,* the evanescence of temporal pleasures. The jeweled pendant, prominently displayed, typifies material, not spiritual, riches.

These objects, then, can be taken on both the narrative and the symbolic level, a habit of thought to which the Dutch were inclined in their search for universal truths in the particulars of daily life. Wtewael's contemporaries could easily have associated them with notions of spiritual cleansing and the vanity of temporal pleasures, commonplaces in the Bible and popular literature. The little still life on the table thus can be taken as an antidote to the adulterous act. Yet pointed moralizing is nowhere to be found. And even in constructing the narrative, Wtewael sustains dramatic tension between the poles of indulgence and retribution, featuring conspicuous eros but also discomfiture, mocking laughter, and a triumphant Vulcan. In so doing, he engages the viewer's wit and conscience, inviting vicarious involvement not only in the coupling but also in its consequences.

This strategy, which pits temptation against the voice of compunction, reflects seventeenth-century ideas about the mechanism of conscience. There is no question that moralists considered erotic imagery dangerous. In 1586, the Dutch Christian humanist writer Dirck Coornhert wrote that contemplating pictures of "a naked Venus" produces "fiery impurity, burning desire, and hot passion."[25] In 1625, the poet Jacob Cats would warn his readers to "avoid lewd pictures painted for those in the service of luxuria, . . . And thus, let art here move you not at all, for even in art lies evil."[26] But theorists of rhetoric found that such images could serve a didactic purpose. According to the tripartite conception of the soul inherited from the ancients, a sensual image like Wtewael's depiction of Mars and Venus appealed to the passions, which resided in the second, sensible, soul; and once the passions were engaged, the effects of the work of art could reach the highest, reasonable, soul, where understanding and will resided, and instruct through reason. If, however, the passions overwhelmed the highest soul, the lowest—appetite, sin, and sensuality—won out.[27] The artist's challenge, then, was to balance appeals to the senses and the intellect, to captivate his audience but not to seduce it. The wittier and more

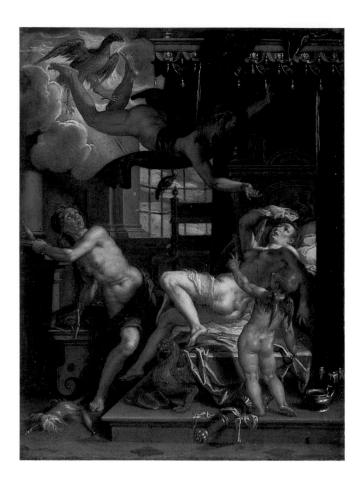

Figure 18
Joachim Wtewael.
Jupiter and Danaë, circa
1606–1610. Oil on
copper, 20.5 x 15.5 cm
(8 x 6⅛ in.). Paris,
Musée du Louvre
(RF 1979–23).

discreet the appeal to conscience, the more effective it must have been. Wtewael gives a consistently deft performance on the didactic tightrope.

The moralizing implicit in the Getty painting would have been more clearly enunciated if, indeed, it was meant to be paired with the *Jupiter and Danaë* in the Louvre [FIGURE 18].[28] This appears to have been the case. Not only are the two paintings virtually identical in size, support, and technique, but they are also compositionally complementary. We find similarly organized and furnished spaces, each with a low platform, an elaborate canopied bed and chair, a breakthrough into depth, and a heavenly radiance at top. A soaring Jupiter domi-

nates both scenes. The two images are also related by the antitheses of the similarly posed Vulcan and the old woman with the distaff—the venerable sign of domestic virtue—with her seen frontally and him from behind. And Danaë's pose conflates and mimics those of Mars and Venus, in reverse.

Moreover, the story of Danaë was traditionally associated with the idea of chastity. When her father, King Acrisios, was warned by an oracle that his grandson would kill him, he sought to forestall the prophecy by removing his daughter from the company of men. His plan failed when none other than Jupiter, enamored, came to her as a shower of golden rain, conceiving Perseus, who in time would indeed kill Acrisios with a discus. Wtewael depicts Danaë as startled by the intrusion, turning aside and raising her arm as if to fend off her would-be lover.

In the Middle Ages, the pure maiden Danaë was even seen as a classical prefiguration of the Virgin Mary. This association evidently survived into Wtewael's time, as we know from a passage in Carel van Mander's *Schilder-Boeck* (*Painter's Book*), published in 1604. Van Mander tells the humorous story of a peasant who mistook a picture of Danaë for a depiction of the Annunciation, thinking Cupid was an angel and Danaë was the Virgin.[29] Van Mander elsewhere, however, interprets the classical story differently, drawing a lesson from it:

> First of all, the fact that the beautiful Danaë, so completely locked
> up, was seduced and impregnated by Jupiter, [who was] changed
> into gold, shows us nothing other than that through riches and
> gifts, by means of the power of unsatiated avarice, one can do and
> accomplish everything; because undoubtedly Jupiter tempted
> and deceived his girl friend and her nurse with lavish gifts of gold.
> One well might say that gold, loved and desired everywhere, sub-
> dues and conquers everything, penetrating the deepest hidden pits
> of the earth, climbing the highest walls, . . . indeed staining pure
> and stout hearts or breasts, and gently making the most earnestly
> raised eyebrows sink, accommodating shame, [destroying] virtue,
> loyalty, honor, and good laws and everything dearer to man than
> his own life.[30]

If we follow Van Mander's reasoning, the story of Danaë is a warning against both lust and avarice, that is, against the dangers of mercenary love.

Van Mander also drew a lesson from the story of the adulterous liaison of Mars and Venus:

> Nothing on earth can protect an evil, godless man from the vengeful hand of God, so that in the end, no matter how long it takes, he will be paid for his misdeeds. It is also a sure thing that one can conceal one's evildoing from men but not from God, who clearly sees into the depths of our hearts and knows our hidden thoughts and desires. Thus there is nothing like a clear conscience, by means of a blameless upright life, to make a man rejoice over gentle peace of mind, unafraid of divine or human wrath. So this story of Mars, who left Jupiter's service and the company of all the gods to be with Venus, illustrates to us how those who abandon God to follow lustful ways come to shame.[31]

The pendant paintings, then, would be variations on the theme of sensual love. "Lustful ways" did indeed pose a threat to the sanctity of home and family and ultimately to the social fabric of the republic. Venus's behavior was far from that prescribed for the ideal woman in Jacob Cats's description of "The Heroic Housewife," from his long verse encomium "Houwelick" (Marriage): "A wife that by all virtue goes, Yet of her gifts but little knows. . . ."[32] As the nation's unofficial voice of conscience, Father Cats set a high standard, but actual Dutch housewives were evidently more robust than the ideal allowed. The English traveler John Ray would note that "the common sort of women seem more fond of and delighted with lasciviousness and obscene talk than either the English or the French." Still, he said "the women are said not much to regard chastity while unmarried but once married none [are] more chaste and true to their husbands."[33] Marital chastity implied orthodox "fleshly conversation," and, to be sure, fidelity.[34] Yet wives did stray, when seafaring husbands were gone for a decade at a stretch.[35] Husbands, too, sometimes looked beyond the marital state for their satisfactions, as we know from paternity suits brought against married men. Adultery, a grievous offense, could be grounds for annul-

ment or divorce.[36] And then there were the brothels, unofficially tolerated and sustained by payoffs, even as their denizens were temporarily banished to the *Spinhuis,* the women's house of correction.[37] Therefore, a painting like Wtewael's could well have touched a nerve among its Dutch viewers. While its erotic imagery might have reflected a certain acceptably playful sensuality, the story, after all, turns on an adulterous liaison. Even if Wtewael's deft moralizing was only pro forma, or ironic, it whispers of a cultural impulse to offer a corrective virtue along with the vice.

To any viewer who is not attuned to the innuendos implicit in Wtewael's depictions of Mars, Venus, and Vulcan, these images might appear to be calls to sexual abandon. And, of course, individual reactions to such a call can range from delight to rejection. In any case, Wtewael's depictions of Mars and Venus were unacceptable to whoever later censored his two preparatory drawings for the Getty and the Mauritshuis paintings [FIGURES 19 *and* 20]. In both, the bodies of the amorous couple have been partially excised. In the study for the Getty painting, the resulting hole has been crudely patched, as if the added drapery had been hastily thrown over the offending nudes.[38]

Censorship aside, the drawings diverge in only minor respects from the paintings, which fortunately escaped the same fate. The spontaneously executed sketch for the Mauritshuis picture [FIGURE 20] appears to have been a compositional study; Apollo, Minerva, and the soaring god are absent, but the other characters are in place. The table at left and the slippers on the floor were not yet a part of the scheme. The low steps in the left corner were to be abandoned in the painting.

Likewise, the study for the Getty painting [FIGURE 19] closely resembles the picture itself; indeed, drawing and painting are virtually the same size. The execution here is also free but is somewhat more detailed; for example, the design of the decorative friezes has been developed. The vignette of Vulcan's forge is as it appears in the painting, with Vulcan at work hammer and tongs at an anvil, his powerful right arm raised to deliver a blow. The figure resembles one in still another drawing by Wtewael in St. Louis, which is probably an independent work rather than a sketch for the Getty picture.[39] In the

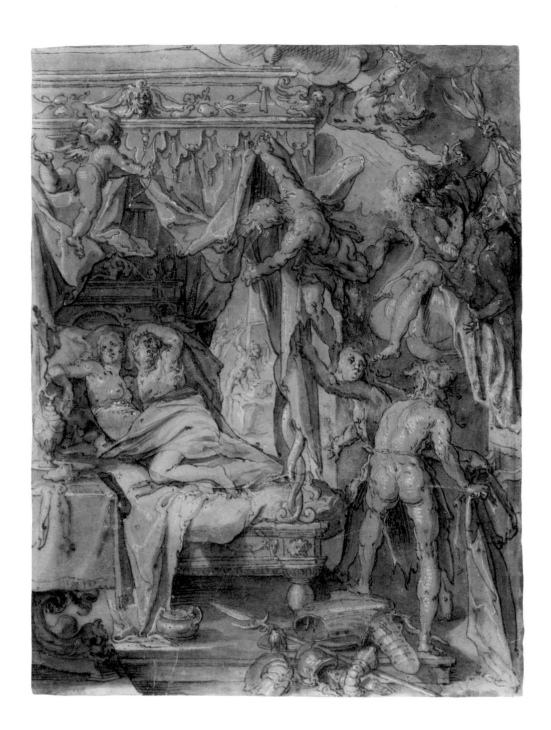

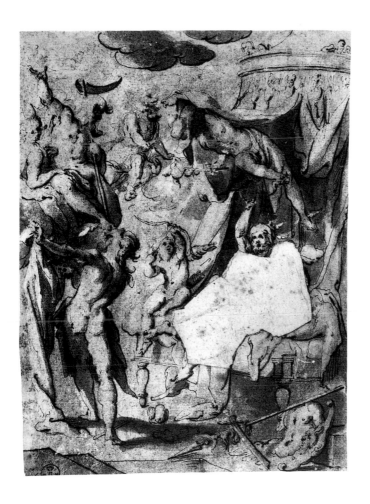

Figure 19
Joachim Wtewael. *Mars and Venus Surprised by Vulcan*. Pen and brown ink, gray and brown wash, heightened with white (partly oxidized), 20.3 x 15.4 cm (8 x 6 in.). Private collection, Europe.

Figure 20
Joachim Wtewael. *Mars and Venus Surprised by Vulcan*, circa 1601. Pen and brown ink and wash, 21.8 x 16.7 cm (8⅝ x 6⅝ in.). Uffizi, Gabinetto Disegni e Stampe (9587 Santorelli).

compositional study, Wtewael had not yet settled on the identities of the characters. The soaring god at the top would be transformed into Jupiter, Jupiter into Saturn, and Mercury into Diana. Otherwise, the drawing corresponds so closely to the painting that it might have served as a presentation sheet for a potential customer.

Who might that customer have been? We know something about Wtewael's clientele, even about buyers for his paintings of Mars and Venus surprised by Vulcan. In his biography of Wtewael, Van Mander named two collectors who owned pictures of the subject. He wrote that a painting on copper had recently been delivered to Jan van Weely, "full of charming, fine work, and so detailed, for the eye enjoys discerning, wonderfully clearly, a table, a couch or bed, with all the gods, and many cupids in the clouds. Another *Mars and Venus* also by him is with Melchior Wijntgis in Middelburg."[40] The painting now in the Mauritshuis, dated 1601, may have been one of these; assuming that Van Mander was writing from memory, the discrepancies are within reason. The other version he mentions has not been found. As we shall see, the Getty painting fits more comfortably among slightly later works.

Both Van Weely and Wijntgis had close contacts with the contemporary artists whose works they bought. Van Weely was an Amsterdam goldsmith, collector, and patron, who, for example, received letters from Hendrick Goltzius about a drawing commission in 1605. Goltzius wrote of both personal and artistic matters, suggesting a close relationship between the two.[41] Van Weely also owned two allegorical paintings, *The Triumph of Virtue* and *The Triumph of Vice,* by Cornelis Ketel, who worked in Amsterdam at that time.[42]

Wijntgis was mint-master of the province of Zeeland in 1601 and former mint-master of the United Netherlands. He must have had a truly splendid collection. In addition to noting the painting by Wtewael, Van Mander commented on an exceptional *Adam and Eve,* a beautiful *Baptism in the Jordan,* and twelve small panels depicting the Passion of Christ by Cornelis van Haarlem.[43] Wijntgis also owned a *Carrying of the Cross* by Van Mander himself.[44] Works by earlier Northern masters included a *Lucretia* by Albrecht Dürer and a *Bacchanal* by Maerten van Heemskerck.[45] An inventory of the collection made in 1618,

after he had moved to Brussels, lists even more extensive holdings.[46] Wijntgis was evidently a close friend of Van Mander, who dedicated to the collector a part of the *Schilder-Boeck,* the didactic poem "Den grondt der edel vry schilder-const" (The Foundations of the Noble, Free Art of Painting).[47] Van Mander there compared Wijntgis, whom he calls "my Maecenas," to legendary patrons like Alexander the Great and the Dukes of Mantua, as well as to Emperor Rudolf II, whose collection of paintings and naturalia was second to none.

The spare descriptions in early sources hardly inform us about how Wtewael's paintings were received. We can situate the depictions of Mars, Venus, and Vulcan in past time and place, but we can never know precisely what degree of titillation, outrage, or amusement they inspired. Wtewael's light touch in the Getty painting leaves room for all three. Van Mander's own reactions ranged from his appreciative description of Van Weely's picture to his judgmental interpretation of the myth. Sympathetic to the paintings as works of art, he nonetheless understood the immorality of the pagan story for his own culture. There is every indication that patrons like Van Weely and Wijntgis were both learned and sophisticated, like the urbane, well-traveled Van Mander.[48] For such collectors, paintings like Wtewael's depictions of Mars, Venus, and Vulcan may have carried the prestige associated with princely patronage, for European sovereigns like Francis I, Philip II, and Rudolf II had favored erotica too.[49] Now *burgerlijk* patrons of the arts could enjoy the status conferred by a daring classical subject, brilliantly depicted on a small copper plate, a treasure like those in aristocratic troves.

THE HISTORICAL NICHE

The Getty Museum's *Mars and Venus Surprised by Vulcan* is signed in the lower right corner, JOACHIM WTEN / WAEL FECIT [*see* FIGURE 8], marking it as the product of a man who left his traces in works of art as well as in notarial documents, guild records, and family papers. Such archival materials together with the biography by Carel van Mander provide glimpses of the life of a successful painter, flax merchant, political activist, and paterfamilias.[50] Despite this archival record, however, Wtewael the man is essentially inscrutable. In the only record he left of his appearance, he looks outward as if at his mirror image, coolly, analytically, at work on this self-portrait [FRONTISPIECE]. It is a formal, public presentation, a claim to status and immortality. On the mantelpiece in the background, below the Wtewael coat of arms, is an inscription that reads "Non gloria sed memoria" (Not glory but remembrance). He looks askance, his body turned, his hands clenched, revealing little of his inner life. Paradoxically, the artist's mind is more accessible in works that are less directly personal. But even here he hints wittily at the character of his art: The unorthodox supporters for his arms are satyrs with cornucopias.

Wtewael painted this self-portrait in 1601, when he was about thirty-five and had been active as a painter for nearly a decade in his native Utrecht. Van Mander tells us that until Wtewael was eighteen, he worked with his father, a glassmaker, and then spent about two years apprenticed to a painter, Joos de Beer, about whom little is known. When he was about twenty, Wtewael set off for Italy, evidently in the company of the bishop of St. Malo, Charles de Bourgneuf de Cucé. After two years in Italy and two in France, Wtewael returned home, having acquired the requisite training and experience to establish himself as an artist.

He thus had been abroad from about 1586 until 1590, years of considerable ferment in the art of the northern Netherlands, which would be a major factor in setting his future course. Haarlem, about eleven miles west of

Amsterdam, was the chief center of activity, thanks to a trio of artists, namely, Van Mander, whom we have already met as a theorist and biographer, and his two younger colleagues, Hendrick Goltzius and Cornelis van Haarlem. Van Mander's age, experience, and intellect—he translated Homer and Virgil—made him a natural mentor to Goltzius and Cornelis. Van Mander had traveled in Italy and had worked in Vienna for Emperor Rudolf II, already mentioned as one of the greatest collectors and patrons of his day. Goltzius, younger than Van Mander by a decade, was then primarily a graphic artist; he would not turn to painting until about 1600. Both Van Mander and Goltzius had come to Haarlem from elsewhere, unlike Cornelis, who, as his name implies, was a native of that city. The youngest of the three, he was a draftsman and painter.

Van Mander had arrived in Haarlem in 1583, and, by his own account, he brought with him some drawings by a fellow Fleming he had met in Rome and later worked with at the Hapsburg court, Bartholomaeus Spranger.[51] Evidently, these drawings were an important source for the figural exaggerations and daring sensuality that soon would enliven the works of Goltzius and Cornelis. As early as 1585, Goltzius would interpret the story of Mars and Venus surprised by Vulcan—the same subject that Wtewael would later depict in the Getty painting—in a manner indebted to Spranger [FIGURE 21]. Although Goltzius claims on the engraving that "invenit sculpsit et divulgavit," that is, he invented, engraved, and published the design, his debt to Spranger is evident in the strange power that seems to have gripped the nude figures. With swelling limbs and small extremities, they twist and strain as if seized by convulsions.

Goltzius's preparatory drawing for the print is in the Getty Museum [FIGURE 22]. Drawing and engraving are nearly identical, though as is typical, they are mirror images, a result of the engraving process. The incised lines on the drawing indicate that Goltzius used it to transfer the design to the engraving plate. He made changes, however, even at an advanced stage. For example, he added several subsidiary figures, such as the two behind the bed, and deleted others. And he adjusted the angle at which Cupid aims; in the print the arrow points more directly at Mercury. The mesh of Vulcan's net is delineated with larger hatchings in the drawing; the engraved hatchings are finer, suggesting the

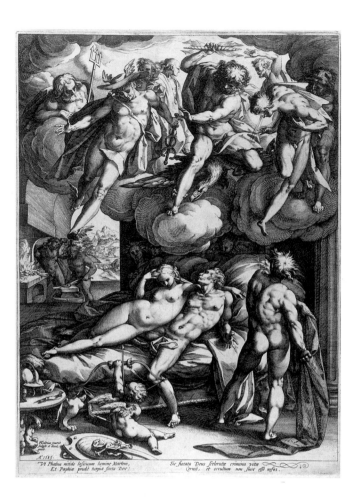

Figure 21
Hendrick Goltzius (Dutch, 1558–1617). *Mars and Venus Surprised by Vulcan*, 1585. Engraving, 42 x 31 cm (16⁹⁄₁₆ x 12³⁄₁₆ in.). Philadelphia Museum of Art, Gift of Mr. and Mrs. Morris L. Weisberg (1986–172–1).

texture of cloth instead of metal. Contrasts of dark and light are indicated in the drawing with washes and in the print with hatchings of exceptional variety, even in this relatively early work.

In four other engravings from 1585, three of which acknowledge Spranger's invention, Goltzius created a world peopled by such exaggerated figures.[52] The Spranger style would be a major source of inspiration for Goltzius and Cornelis for the next five years, yielding drawings and engravings full of fantasy and sometimes outrageous inventiveness.[53] By 1590, however, Goltzius was

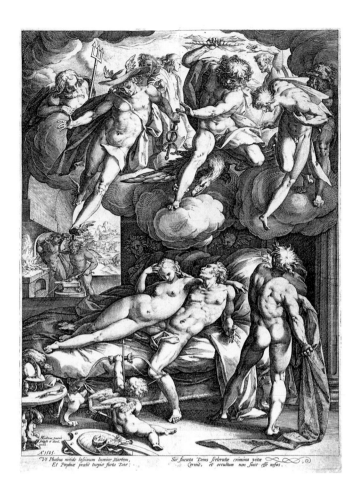

Figure 22
Hendrick Goltzius. *Mars and Venus Surprised by Vulcan,* 1585. Pen and brown ink, brown wash, white gouache heightening and black chalk, 41.6 x 31.3 cm (16 3/8 x 12 5/16 in.). Malibu, J. Paul Getty Museum (84.GG.810).

ready for a change. In October of that year, he set off for Italy, a journey that marked a decisive turning point. Upon his return to the Netherlands, he no longer engraved after Spranger.

While Goltzius's interest in the flamboyant style had run its course by the early 1590s, other artists were just discovering its possibilities. Having made engravings after Goltzius's designs in 1589, the Amsterdam artist Jan Muller was steeped in the Haarlem style. We discover it in his own works from around 1590, such as his drawing *Embracing Couple,* which probably depicts Mercury

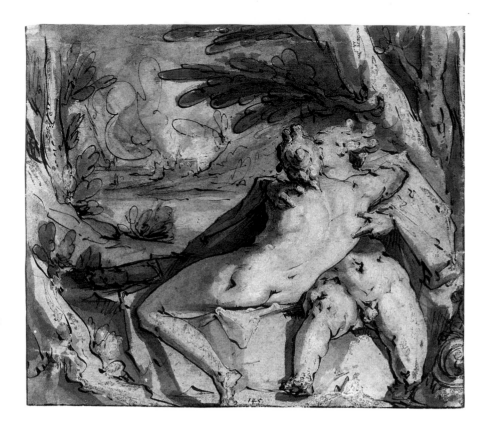

Figure 23
Jan Muller (Dutch,
1571–1628). *Embracing
Couple (Mercury and
Lara?)*, circa 1590. Black
chalk, pen and brown
ink, brown wash, and
white gouache heighten-
ing, 18.7 x 21.7 cm
(7 3/8 x 8 9/16 in.). Malibu,
J. Paul Getty Museum
(86.GG.595).

and the nymph Lara [FIGURE 23]. Like Goltzius and Cornelis, Muller borrowed
ideas from Spranger, here deriving the poses from the composition of a *Lot and
His Daughters* that Muller engraved after a drawing by Spranger.[54] But he has
changed the subject, revised the setting, and worked in his own distinctive
variation of the Spranger style. While retaining conventions like stiffened, blocky
fingers and looping foliage forms, Muller favored forceful contrasts, strong con-
tours that are alternately fluent and agitated, and dark flicks of the pen that
animate the design. Muller's drawing style owes much to that of Cornelis van
Haarlem.[55] The Getty drawing reflects the complex interconnections among
this group of artists and the occasional difficulty in sorting out their individual
styles.

Indeed, a drawing of Mars and Venus in the Getty Museum now recognized as the work of Abraham Bloemaert [FIGURE 24] was once attributed to Spranger, as the inscription in the lower right corner indicates. That attribution is not surprising, in view of the swelling and tapering limbs and the forms that twist and intertwine. Moreover, the entire conception seems to have been derived from an engraving by Goltzius after Spranger, a *Mars and Venus* of 1588, where the couple also embraces beneath a tentlike canopy, flanked by two putti

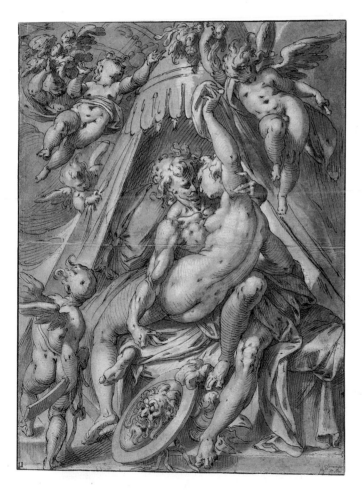

Figure 24
Abraham Bloemaert
(Dutch, 1564–1651).
Mars and Venus, circa
1592. Pen and brown
ink, brown wash, white
gouache heightening over
traces of black chalk,
41.2 x 30.2 cm (16 ⁷/₁₆ x
11⁷/₈ in.). Malibu,
J. Paul Getty Museum
(88.GG.40).

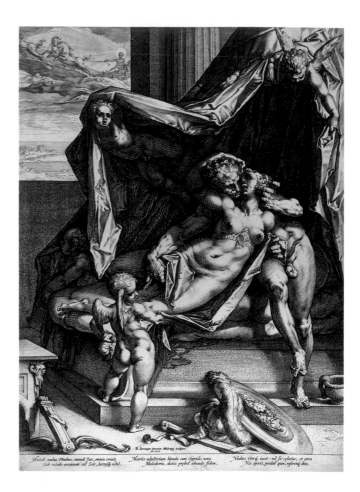

Figure 25
Hendrick Goltzius after
Bartholomaeus Spranger.
Mars and Venus, 1588.
Engraving, 44.1 x
31.3 cm (17⅜ x
12⁵⁄₁₆ in.). Philadelphia
Museum of Art, Muriel
and Philip Berman
Gift Acquired from the
John S. Philips Bequest
of 1865 to PAFA, with
funds contributed by
Muriel and Philip Berman
and the gifts (by
exchange) of Lisa Norris
Elkins, and others
(1985–52–1465).

and accompanied by Cupid at the lower left [FIGURE 25]. But Bloemaert has not simply copied Spranger; rather, he has reworked his ideas, for example, retaining the pose of Mars while turning Venus around. In revising the engraving he was following rhetorical principles that valued ingeniously surpassing a given model.[56] Bloemaert's artistic character is evident in the technique. Energy that enlivens the figures also infuses the execution, in the curved hatchings that model forms and small V-shaped accents within the figures that record agitated movements of the pen, a "mannerism" that Bloemaert, like Muller, adopted

from Cornelis and individualized. The supple contours and features like wind-blown locks of hair and pug-nosed putti are characteristic Bloemaertian motifs. Bloemaert also elaborated on Spranger's ideas by developing the theme of Mars's power: Putti that attend the embracing couple carry a phallus, at the upper right, and a sword, at the lower left. The diagonal line of force that links them sweeps through the body of Venus.

Bloemaert had been trained in Utrecht, but in 1591 he moved to Amsterdam, where he spent about three years. There, he too responded to the impact of the Spranger style, which had spread from neighboring Haarlem. By late 1593 Bloemaert had returned to Utrecht, not long after Wtewael had come home from his four years of travel abroad. Bloemaert helped to introduce Wtewael to the new manner, which the two artists would continue to explore throughout the 1590s. Wtewael's *Lot and His Daughters* [FIGURE 26] exemplifies his large works of this time.[57] The composition in all probability antedates 1604, since it accords with that of a painting Van Mander described in his biography of Wtewael, published in that year. Like Bloemaert, Wtewael studied Goltzius's works; he quotes his engraving of Bacchus in the motif of Lot's upraised hand holding a tazza.[58] Wtewael removed the Old Testament scene from the arena of real experience, creating a world in which figures strain to hold taut poses in a claustrophobic space conjured up with exotic, arbitrary color. Then, as if to underscore the artifice, he added a contrasting note of normalcy in the still life, which is wonderfully rich in observed detail.

As in the Getty painting, Wtewael dramatizes the notorious scene so as to engage the viewer in interpreting the story. His imagery conveys the ambivalence that pervades discussions of Lot in the exegetical literature. Was he a good man because he obeyed the Lord and left sinful Sodom, or was he himself sinful because he succumbed to drunkenness and incest? Were his daughters innocent because, believing they were the last people on earth, they seduced their father in order to perpetuate the human race? Or were they, too, guilty of the sin of lust? By featuring objects that can be interpreted in many ways, some negative and some positive, Wtewael raised rather than answered questions. The daughter who strokes her father's beard holds a

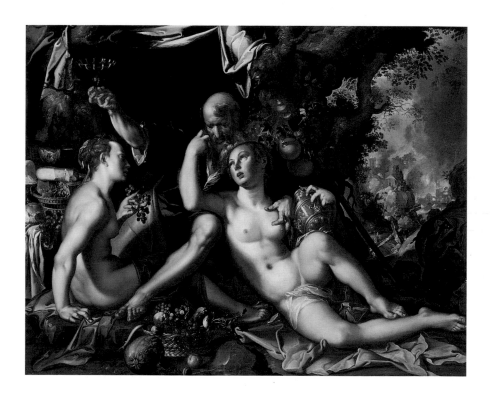

magnificent ewer that could hold either the wine of inebriation or, metaphorically, the water of cleansing. The staff and gourd are emphatically sexual in form and connotation, but they are also attributes of pilgrims, appropriate to Lot on his flight to salvation. Since Wtewael activates conflicting overtones, all of which are appropriate in the context of the story, he creates a "moral dilemma," leaving it to the viewer to ponder the possibilities and their consequences.[59]

As Van Mander would later write about Wtewael, "one could not readily say where he is more outstanding, in large or in small."[60] Wtewael's ver-

satility is revealed even in his earliest works, which are exceptionally diverse in size, subject, and style. The *Lot and His Daughters* is over five feet high and six feet wide, and the story is from the Old Testament. Perhaps at the same time Wtewael was at work on this large canvas he was involved with quite a different project, a mythological scene on a small copper plate, the *Mars and Venus Surprised by Vulcan,* dated 1601, in the Mauritshuis [FIGURE 15].

Wtewael here again used engravings by Goltzius, rethinking and varying his ideas. Goltzius's *Mars and Venus Surprised by Vulcan,* from 1585 [FIGURE 21], provided the basic compositional scheme, with an earthly and a heavenly realm. But while adopting that arrangement, Wtewael revised poses, rearranged figures, and remodeled furnishings. He took the canopied bed, its curtains raised by an airborne figure, from Goltzius's engraving *Mars and Venus* of 1585 [FIGURE 25], together with the square table and the chamber pot. Finally, Wtewael varied the sexual narrative by showing Mars and Venus not only nude but also coupled. When we translate the Latin inscription on the engraving of 1588, we hear the moralizing of humanist scholars: "Just as Phoebus, the god of the sun, reveals with his shining light the lustful Mars and the secret infamy of Venus, so does God discover the crimes of an evil life and prevents sinful things from remaining hidden." Working in a different medium, Wtewael was able to impart a more subtle moral message.

The date of 1601 inscribed on the Mauritshuis painting provides a useful starting point for dating the Getty picture of the same subject. In comparison, the Mauritshuis *Mars and Venus Surprised by Vulcan* is more restrained in both expression and spatial organization. The mood is more somber than jovial, and the gestures are less energetic, in part because the figures are slight rather than robust. The tonality is cooler than that of the Getty painting, with predominantly pale flesh tones and silvery clouds. The composition is, however, complex and dynamic, with angular lines of force leading into depth, although not to Vulcan's forge. The two paintings are virtually identical in size, but the Hague picture seems more diminutive. As already noted, this is most likely one of the small vertical depictions of Mars, Venus, and Vulcan that Van Mander described in the biography of Wtewael.

The Getty painting fits more comfortably with slightly later works by the artist. A few years after the turn of the century, he developed a style that was both more expansive and more structured. Another dated mythological scene offers a useful comparison with the Getty picture, a *Wedding of Peleus and Thetis* of 1610 [FIGURE 27].[61] The figures are now more substantial, the hues saturated. The composition is dense but ordered, with deities wreathing the wedding table, which angles back into depth. Masculine bodies are wiry and muscular, feminine ones softly articulated. Even more important, each character's inner life is suggested through sensitive, varied facial expressions. These features also characterize the Getty painting, despite the differences in size and support. A date of around 1610 therefore seems right.[62] Even then, decades after the heyday of the Haarlem style, Wtewael was still studying Goltzius. The pose of Vulcan in the Getty picture only slightly varies that of the god in Goltzius's engraving *Mars and Venus Surprised by Vulcan* [FIGURE 21]. And, as in the print, we glimpse Vulcan's forge in the background.

Admittedly, the stylistic shift in Wtewael's works during the first decade of the century is modest. The movement is toward a more stable and expansive compositional structure and a wider range of psychological expression. Although he moderated the Haarlem style, Wtewael did not abandon its characteristic artifice. Rather, he refined it. He would continue to do so into the 1620s, as his *Moses Striking the Rock,* dated 1624, reveals.[63]

So far the Haarlem style and its ramifications have been discussed without the label usually applied to it, namely "Dutch mannerism." Letting each work speak for itself avoids the preconceptions that such labels sometimes generate and allows the concept of style to emerge from the features and devices common to the images. It might now be helpful to summarize these features in an overview of Dutch mannerism, in order to bring to the fore some of the artistic principles and cultural forces that were at work in Wtewael's time.

These developments are firmly rooted in earlier sixteenth-century European art. The term mannerism is derived from the Italian word *maniera,* which has approximately the same range of meanings as our word "style," carrying, for example, connotations of both stylishness and stylization. It was not

Figure 27
Joachim Wtewael.
*The Wedding of Peleus
and Thetis,* 1610. Oil on
panel, 109 x 165 cm
(43 x 65 in.). Providence,
Museum of Art, Rhode
Island School of Design,
Mary B. Jackson Fund
(62.058).

until the late eighteenth century that "mannerism" was coined to characterize a dominant trend in sixteenth-century Italian art. Now, however, the term is more broadly applied, and the origins of the trend are recognized as more complex, lying both north and south of the Alps. The Netherlands as well as Italy provided a hospitable environment for its genesis and growth.[64] As we shall see, in the first years of the sixteenth century, independently of Italy, Netherlanders began to use a vocabulary of forms that comprises what historians now recognize as a mannerist approach.

As the century unfolded, this approach would spread throughout Europe. One of its fundamental characteristics is an emphasis on the artist's idiosyncratic vision rather than on an objectively valid view of the world, that is,

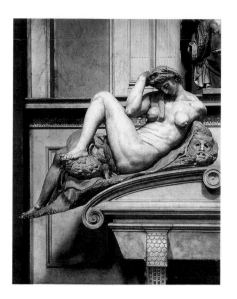

Figure 28
Michelangelo Buonarroti
(Italian, 1475–1564).
Night, 1524–1534.
Tomb of Giuliano de'
Medici, Florence, New
Sacristy, San Lorenzo.
Photo: Alinari.

on subjective rather than empirical truth. The formal conventions with which this was expressed include elongated or otherwise distorted figures in elaborate poses, often with erotic overtones; ambiguous spatial effects; and arbitrary ornamental color. Complex invention and difficult techniques were prized, for the virtuoso artist could then appear to rise to any challenge with seemingly effortless grace. His wit could produce bizarre fantasy, sometimes through the capricious quotation of motifs that thereby acquired surprising meanings in unexpected contexts.

The Getty *Mars and Venus Surprised by Vulcan* exemplifies such an approach. Rising to the challenge posed by the complexities of Michelangelo's heroic nudes, Wtewael quotes, in reverse, the figure of Night, from the tomb of Giuliano de' Medici [FIGURE 28], in the combined figures of Venus and Mars, thus imbuing them with an odd thematic resonance.[65] His play upon the original subject, changing the medium from sculpture to painting and the scale from the monumental to the miniature, typifies mannerist wit. So do Wtewael's elaborate arrangements of human bodies, seen from odd angles, flexed and extended and twisted into surprising shapes. Anyone who tries to arrange his or her body

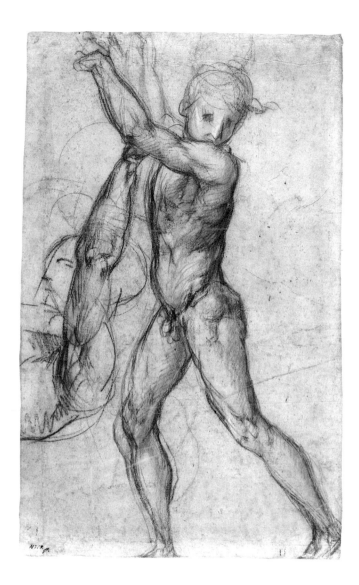

Figure 29
Jacopo Pontormo
(Italian, 1494–1556).
Study of a Nude Boy,
1518. Red and white
chalk, 38.9 x 24 cm
(15⁵⁄₁₆ x 9⁷⁄₁₆ in.). Malibu,
J. Paul Getty Museum
(87.GB.95).

in the pose of Wtewael's figure of Vulcan understands at first hand that this "realistic" muscular body moves in uncomfortably exaggerated contrapposto.

Because mannerism deviates from the norm, it is often called an anti-natural style, but, as we have already seen, this oversimplifies the situation. Even an image drenched in mannerist fantasy can hold fully naturalistic elements,

generating an interplay between the two modes and acknowledging naturalism as a matter of art, an aesthetic choice like any other. In the Getty painting, illusionistic textures—of metal, fabric, flesh—inform a conception generally at odds with everyday experience. The spatial organization is at once plausible and irrational. Wtewael simultaneously convinces us of his mimetic skill and demonstrates his renunciation of it. The conception of mannerism as an anticlassical style is similarly misleading. Although the first mannerist generation in Italy reacted against the classical visual canons of the High Renaissance, classical themes featuring the human nude sustain many an image that breaks from classic norms, the Getty *Mars and Venus Surprised by Vulcan* among them.

We can outline the origins and development of the mannerist trend using a small selection of works from the Getty Museum, whose holdings are rich in this area. A drawing by Jacopo Pontormo, a chalk study of 1518 for the figure of a putto in the *Madonna with Saints,* an altarpiece for the Florentine church of San Michele Visdomini [FIGURE 29], is among the earliest Italian experiments in the new direction.[66] On the recto of the sheet, Pontormo sketched two figures, concentrating on the striding figure of a nude boy, who moves with a seemingly normal gait but appears strangely weightless, with his torso upright and balanced over his legs, his arms raised, energy arrested in an elegant formal display. Contours and schematic notations, rather than internal modeling, establish the anatomy, yielding a certain abstraction. The boy averts his gaze, his downcast hollow eyes expressing an inner state that contravenes any external goal. Pontormo has recast the plausible physicality and extroversion of his predecessors into a subjective vision.

In the Netherlands, too, mannerism arose in the first years of the sixteenth century, when classical impulses merged with the late Gothic that had flourished in northern Europe in the 1400s. The so-called Antwerp mannerists, at work in that city in the first decade of the century, produced paintings of an extraordinary richness, complexity, and inventiveness, full of the conventions described above. The stylish new way of working also caught on elsewhere. Bernaert van Orly explored it in Brussels, where he was employed at the Hapsburg court. A *Holy Family* in the Getty Museum [FIGURE 30], probably from

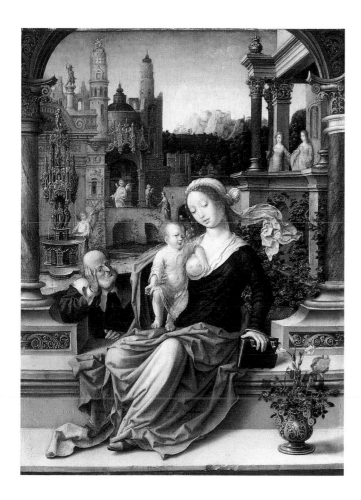

Figure 30
Studio of Bernaert van
Orly (circa 1488–1541).
The Holy Family, 1520s.
Oil on panel, 45.5 x
33.5 cm (18 x 13¼ in.).
Malibu, J. Paul Getty
Museum (71.PB.45).

Van Orly's studio and datable about 1520, displays elegant playfulness in the reworking of motifs from earlier Netherlandish art and the classical past.[67] The Christ Child almost levitates on his mother's lap in a contrapposto pose. The three family members are all placed in the immediate foreground, but there is a marked disparity in size between mother and child and Joseph, a hierarchical device that indicates his subsidiary importance as Christ's foster father. Mary's veil moves with a life of its own, animated by a breeze that leaves all else untouched. The setting is a courtyard full of architectural fancies, with Gothic

Figure 31
Joachim Beuckelaer
(Flemish, circa
1530–circa 1573). *The
Miraculous Draught of
Fishes,* 1563. Oil on
panel, 110.5 x 221 cm
(43½ x 83 in.). Malibu,
J. Paul Getty Museum
(71.PB.59).

and classical elements freely combined in a disjunctive space. Throughout, an emphasis on imaginative interpretation of the past removes the scene from ordinary experience but can be justified as appropriate to the creation of a heavenly realm for the Holy Family.

Landscape has its own traditions, but in this genre, too, certain conventions signal a mannerist approach. Joachim Beuckelaer, who worked in Antwerp at mid-century, introduced conspicuous artifice into his *Miraculous Draught of Fishes,* of 1563 [FIGURE 31]. A colorful crowd of fishermen and women, unloading, counting, and sorting a catch into baskets, almost distracts us from the background, where Beuckelaer depicted episodes from the biblical story (John 21:4–11). In muted gray-green tones, the apostles let down their nets from the vessel at left; Saint Peter wades ashore, having recognized the risen

Christ, who appears twice, standing to greet Peter and sitting among his disciples beside fish roasting on a fire. The foreground bursts with the vitality and diversity of real experience. A man lowers a bucket from the bow of the boat close to shore, while a boy on the toe rail adjusts the rigging. An official who tallies the catch leans over to watch a fisherman carefully placing fish across one another. And at this point we slip onto another level of discourse, reminded that the Greek word for fish, *ichthus,* formed the initials of the words Jesus/Christ/of God/the Son/Savior. Thus since early Christian times, fish have figured variously in symbols of Christ and his followers. Beuckelaer exploits that symbolism by showing the creatures' bodies crossed, a thinly disguised allusion to the Crucifixion. He places that detail directly below the background depiction of Saint Peter's faith in Christ, inviting us to draw a lesson in faith from the humble event on the beach. The interplay between the colorful foreground, so close to contemporary Netherlandish life, and the muted background, removed to the distant biblical past, parallels the negotiations between physical and spiritual life that characterize all human experience. Beuckelaer's use of mannerist conventions such as spatial disjunction and unnatural color therefore is not simply an arbitrary formal choice but is also appropriate to this complex artistic statement.

Late in the century, Jan Brueghel the Elder would depict another outdoor biblical scene in his *Landscape with Saint John the Baptist Preaching,* of 1598 [FIGURE 32]. Some three decades after Beuckelaer, Brueghel continued to work with the same conventions, virtually burying the main figure, Saint John, in a massive crowd. He challenges the viewer to find him, almost teasingly. And there he is, a small figure at a makeshift pulpit in the left middleground, his importance conveyed by the respectful space and luminosity around him. Like Beuckelaer, Brueghel manipulates our experience of the landscape, organizing it into strata of shadow and sunshine, causing some boughs of the trees to stand out in bright light, others to recede into darkness. The trees bend obligingly to shelter the Baptist. The technique of oil on copper was an ideal vehicle for Brueghel. He virtually fills the scene with infinite details of figures and foliage, releasing us into the distance only at the right, where the forest gives way to a harbor and distant mountains. His color choices are rooted in reality, but the

Figure 32
Jan Brueghel the Elder
(Flemish, 1568–1625).
*Landscape with Saint
John the Baptist Preach-
ing*, 1598. Oil on copper,
27 x 37 cm (10½ x
14½ in.). Malibu,
J. Paul Getty Museum
(84.PC.71).

Figure 33
Attributed to Hans
Mont (Flemish, active
1571–1584). *Mars
and Venus,* circa 1575.
Bronze, H: 54 cm
(21 in.). Malibu,
J. Paul Getty Museum
(85.SB.75).

bright pinks, blues, and reds of the foreground and the bronzes and blue-greens of the foliage elaborate on ordinary visual effects. Here, as in Van Orly and Beuckelaer's paintings, there is an emphasis on the artist's imaginative constructions rather than on verisimilitude. And once again formal conventions serve an expressive purpose. With his miniaturist's technique, Brueghel creates an analog for life's endless distractions and illustrates a range of reactions to the Baptist's words in a crowd of Netherlandish and biblical folk. A beast's skeleton, isolated in the corner and eyed by a child in the retinue of a fine lady is a *vanitas* motif that reminds us of the importance of listening.

The mannerist sensibility could be expressed in any artistic medium. We find it in a bronze sculpture of *Mars and Venus* in the Getty Museum [FIGURE 33], attributed to the Flemish sculptor Hans Mont.[68] The two deities embrace with elegantly elongated limbs, their impassive faces almost touching but betraying no hint of emotion, their bodies self-consciously arranged for aesthetic effect. Opposites attract: Venus's softly curving pose contrasts with Mars's rectilinear one, smooth bodies with a curving fall of drapery, nudity with an

elaborate coiffure and a fabulous helmet. Passion is stilled in favor of a cool abstraction of love. In 1575, the time when this sculpture was probably made, Mont was recommended by his teacher, Giovanni Bologna, to the Hapsburg emperor Maximilian II. Another Flemish artist, Bartholomaeus Spranger, came with him to Vienna. Two years later, Mont and Spranger would collaborate with none other than the young Carel van Mander on a triumphal arch to celebrate the entry into Vienna of the new emperor, Rudolf II. This concatenation would be crucial for the art of the Netherlands. We have come full circle, to the point at which Van Mander's introduction of his friend Spranger's art to Hendrick Goltzius and Cornelis van Haarlem would generate a major creative outburst in the northern Netherlands in the 1580s.

This phenomenon, though short-lived and circumscribed, marks an extraordinary period in Netherlandish art, during which many commonly held notions about the character of that art were upset. The decades around 1600 saw bold experimentation, an embracing of international crosscurrents, and an intellectually ambitious program attuned to sophisticated patronage. Wtewael's *Mars and Venus Surprised by Vulcan* is a quintessential expression of the time. The extravagance of the tale and its "mannered" telling, the whole primarily an example of marvelous artifice, thematized in the myth itself by Vulcan's net, certifies Wtewael's special kind of virtuosity.

VARIATIONS

In Shakespeare's heroic narrative poem *Venus and Adonis,* published in 1593, the love goddess chides the hunter for resisting her, unlike the dashing Mars:

> Over my altars hath he hung his lance,
> His batter'd shield, his uncontrolled crest,
> And for my sake hath learn'd to sport and dance,
> To toy, to wanton, dally, smile, and jest;
> Scorning his churlish drum, and ensign red,
> Making my arms his field, his tent my bed.
>
> Thus he that overrul'd, I oversway'd
> Leading him prisoner in a red-rose chain:
> Strong-temper'd steel his stronger strength obey'd,
> Yet was he servile to my coy disdain,
> O be not proud, nor brag not of thy might,
> For mastering her that foil'd the god of fight.

> (103–114)

Shakespeare's verses, almost contemporary with Wtewael's depictions of Mars, Venus, and Vulcan, belong to a body of texts and images featuring the liaison that reaches from antiquity into the nineteenth century. Scanning several of these will provide a frame of reference for Wtewael's paintings of the subject. The mythical adultery inspired remarkably varied interpretations in literature, sculpture, the graphic arts, and painting. The subject was just as popular with Dutch mannerists as it was with other generations of artists and writers.[69]

Long before Ovid had told the tale of Venus's dalliance with the god of war, quoted at the outset of our first chapter, Homer had recounted it in the *Odyssey* (8.266–366).[70] Because so many details of Homer's version were picked up by later artists, it bears review here. In Book Eight, Odysseus is entertained

47

by the Phaiakians at a marvelous feast followed by athletic games. Afterwards, the floor is smoothed, and the blind Domodokos, amidst young dancers beating the rhythms with their feet, sings the story of Mars, Venus, and Vulcan (in Greek, Ares, Aphrodite, and Hephaistos). The song is more expansive than Ovid's narrative, providing dialogue, more incident, and deeper characterization. Domodokos places the scene of the love affair in Hephaistos's own house. Alerted to the deception by Helios (Apollo), the distraught Hephaistos made his way to the smithy to vent his anger and seek revenge, fashioning a net too fine to see but too strong to break. Carrying the treacherous snare back to his bed chamber, he spun the fastenings around the posts from every direction "thin, like spider webs" (an image Ovid would later adopt). Hephaistos feigned a journey to Lemnos, whereupon Ares and his love "went to bed together and slept there, and all about them were bending the artful bonds that had been forged by subtle Hephaistos." His heart grieved, Hephaistos "gave out a terrible cry and called to all the immortals: 'Father Zeus and all you other blessed immortal gods, come here, to see a ridiculous sight, no seemly matter, how Aphrodite, daughter of Zeus, forever holds me in little favor, but she loves ruinous Ares because he is handsome, and goes sound on his feet, while I am misshapen from birth, and for this I hold no other responsible but my own father and mother, and I wish they never had got me.'" And the gods gathered—Poseidon, Hermes, Helios—but the goddesses remained home, out of modesty. When they saw "the handiwork of subtle Hephaistos, the gods broke out in uncontrollable laughter," saying "'No virtue in bad dealings. See, the slow one has overtaken the swift, as now slow Hephaistos has overtaken Ares, swiftest of all the gods on Olympos, by artifice, though he was lame, and Ares must pay the adulterer's damage.'" But when Helios asked Hermes if he would trade places with Ares, he readily agreed "'I wish it could only be, and there could be thrice this number of endless fastenings, and all you gods could be looking on and all the goddesses, and still I would sleep by the side of Aphrodite the golden.'" Finally, amidst continuing laughter, Hephaistos acceded to Poseidon's guarantee of vindication and set Ares free. He promptly headed for Thrace, and Aphrodite returned to her sacred precinct on Cyprus, where the Graces bathed and anointed her.

Domodokos's choice of subject is ironic, since the *Odyssey* turns on the theme of marital fidelity, of Penelope's chastity and the threat posed by her husband's absence. The tale is a foil for Penelope's exemplary love for Odysseus. Her loyalty and modesty create a feminine ideal in utter contrast to Aphrodite. Aphrodite is not reproached in Homer's account, but neither is Hephaistos, her cuckolded husband, humiliated. On the contrary, he wins sympathy and praise for his ingenuity. There is a trace of moralizing in the gods' aphoristic comments, yet they respond to the ensnared lovers with the proverbial Homeric laughter, derisive but nonetheless amused. Hermes's ready acceptance, in fantasy, of the consequences of illicit love also bespeaks an indulgent acceptance of its vagaries, and, of course, the episode ends with no lasting damage.[71]

Ovid, too, juxtaposes mundane and heavenly spheres in Book Four of the *Metamorphoses*. The daughters of Minyas are avoiding the Theban Bacchic revels, staying indoors to ply their household tasks. As they spin their wool, they take turns telling stories "to beguile the tedious hours."[72] Leuconoë regales her sisters with the story of Mars and Venus's love affair. She introduces it with the comment that "Even the Sun, who with his central light guides all the stars, has felt the power of love."[73] After telling of Apollo's revelation of Mars and Venus, she continues with the story of the sun god's hopeless love for Leucothoë. As Ovid evokes the scene of the daughters of Minyas "spinning yarns" and links the myths concerning Apollo, he skillfully weaves the stories together into a captivating narrative devoid of judgmental comment.

Ovid had perhaps been more didactic in his *Ars amatoria,* or *The Art of Love* (2.561–598), but with practical, not moralizing, intent, for the book provides complete instructions on the conduct of love affairs. He offers advice: "Wherefore all the more, O lovers, detecting your mistresses; let them err, and erring think they have deceived. Detection fans the flame of passion; where two have shared misfortune, each persists in the cause of his own fall." He illustrates his point with the story of Mars, Venus, and Vulcan, expressing skepticism over the wisdom of Vulcan's cleverness. Moreover, he scolds the Sun for tattling: "Request a privilege from her: you too she will oblige, if you will but hold your tongue."[74] Thus Ovid rebukes not the adulterous couple but those who were

scandalized by their affair. His account is marked more by a suave humor than by pangs of conscience, an attitude that reflected the indulgences of Augustan Rome and perhaps was a factor in Ovid's banishment from the city.[75]

Although ancient writers told and retold the story of the misadventures of Mars and Venus, ancient visual artists seem not to have depicted it with any frequency. Indeed, the surviving evidence includes no certain Greek representation.[76] There are several Roman ones, however, such as those on sarcophagi from the second century A.D.[77] The classical archeologist Johann Winckelmann published an engraving of one such relief in 1767, altering its proportions and devising some reconstructions but retaining its essential features [FIGURE 34].[78] The sedate *dramatis personae* are strung out in a static arrangement; with the help of gestures, facial expressions, and costumes, we can decipher the narrative. It begins at the left, where Concordia presides over the marriage of Vulcan and Venus, their right hands joined in the *dextrarum iunctio,* a symbol of union and accord. But the pledge of fidelity was not to be kept. Apollo, holding a laurel branch, regards the hapless Vulcan, now betrayed by his wife and displaying the sorry scene to the gods. Beside him stands Helios, the informing Sun, crowned by light rays and carrying a whip with which to speed the horses of his chariot.[79] Jupiter, his eagle beside him, raises a chastening finger at Mars, who sits despondently on the bed beside his erstwhile lover. Cupid tries to hide behind the curtain, but his companion, ever hopeful, still holds high the torch. Venus turns away from Mars toward the fleeing winged god of sleep, Hypnos.[80] Mercury brings the story to a close. There is no hint here of the Homeric laughter that enlivens the *Odyssey* passage. Rather, the mood is serious and admonitory.

The presence of the fable on a funerary monument raises the intriguing question of its relationship to the life it commemorated. The answer probably lies in an esoteric allusion, perhaps an astronomical reference to the conjunction of the planets Mars and Venus. Some say that the couple begot a daughter named Harmonia, who signified the union of beauty and strife, of the generative and destructive forces of nature.[81] Or, the choice might have been inspired by the elaborate theories of the Pythagoreans, who saw in Mars the

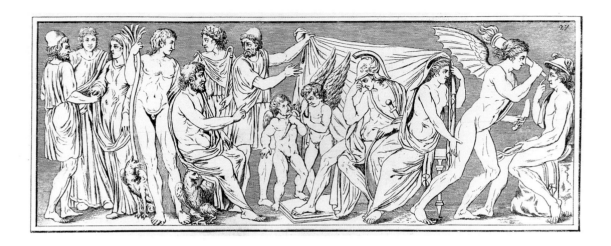

body, which sustains life blood, in Venus the soul, which seizes love in its corporeal envelope, and in Vulcan the demiurge that links body and soul.[82]

Ovid's *Metamorphoses* survived through the Middle Ages, often embellished with commentaries, which in the fourteenth century took the form of "moralized Ovids." One popular version was the *Ovidius moralizatus* of about 1340 by the French Benedictine monk Pierre Bersuire, better known by his Latin name, Petrus Berchorius. He mines the story of Mars, Venus, and Vulcan not for a moral message but for a bit of practical wisdom. Citing Deuteronomy 22:10, "Thou shalt not plow with an ox and an ass together," he observes that the union of Vulcan and Venus was doomed from the start. When ugly husbands are mismatched with beautiful wives, adultery is sure to follow.[83]

The classical tradition lives on in another *Metamorphoseos vulgare* (Venice, 1497; Parma, 1505). It exemplifies Renaissance reverence for antiquity. Ovid's Latin text is accompanied by a newly composed Latin commentary together with a woodcut illustration of classical design [FIGURE 35]. Here, as

Figure 34

Mars and Venus Surprised by Vulcan (sarcophagus, Roman, 2nd century A.D.). Engraving from Johann Winckelmann, *Monumenti antichi inediti* (Rome, 1821), vol. 1, no. 27. Avery Architectural and Fine Arts Library, Columbia University in the City of New York.

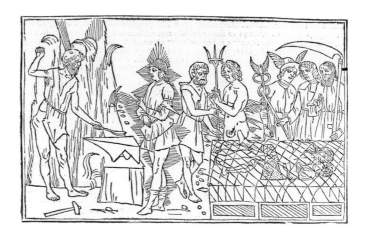

Figure 35
Mars and Venus Surprised by Vulcan. Woodcut from the *Metamorphoseos vulgare* (Venice, 1497; Parma, 1505). Cambridge, Houghton Library, Harvard University.

on the sarcophagus, order and clarity prevail as the narrative unfolds. It begins at the left, with Vulcan interrupted by a visitor to his forge, none other than the radiant Apollo, here conflated with Helios. Vulcan's revenge, at the right, shows the lovers immobilized and scrutinized by Mercury and two colleagues; Neptune negotiates with Vulcan nearby. The contemporary Latin commentary essentially provides footnotes to Ovid's text without adding a point of view. Revitalizing the ancient myth was evidently sufficient.

In comparison with these formal stagings of the story of Mars, Venus, and Vulcan, medieval interpretations seem positively domestic, with the well-blanketed lovers tucked into bed. Christine de Pisan, born in Venice but active in France, followed that precedent in her book *Epitre d'Othéa,* written about 1408–1415 and illustrated by Parisian illuminators [FIGURE 36].[84] The mise-en-scène is Venus and Vulcan's bedroom, with a nude Venus and Mars in a canopied bed made up with white sheets, a green coverlet, and pillows like those of today. Mars dozes, but Venus looks wide-eyed at two strangers, gods whose saddened faces and gestures register their dismay. They have been summoned by Vulcan, who crouches beside the bed and draws back a heavy-linked chain as if to display his catch. A brilliant orange Apollo peers through the open window beyond, his sunlight revealing all.

At the time she wrote the *Epitre d'Othéa,* de Pisan lived in Paris and

Figure 36
*Mars and Venus
Surprised by Vulcan.*
Illumination from
Christine de Pisan,
Épitre d'Othéa (Paris,
circa 1408–1415).
London, British Library
(MS Harley 4431).

worked in the circle of Charles VI. Othéa (the Greek vocative commonly used in Homer in speeches to Athena) is the Goddess of Prudence, or Wisdom, who instructs her protégé Hector on how to reach true knighthood through virtue. In the text, epistles in verse are followed by de Pisan's gloss on Othéa's supposed teaching. The moral precepts and spiritual lessons addressed to Hector, the fifteen-year-old hero, were written above all for the young men in the entourage of Louis d'Orléans, to whom the earliest manuscript copy was dedicated.[85] Thus de Pisan observes that a good knight should behave as if he were to die any minute. Warming to her topic, she continues "Saint Leo the pope says to this, that the old enemy, the which transfigured himself into an angel of light [Lucifer], says not to stretch his snares or temptations over all and to spy how he may corrupt the faith of good believers; he beholds whom he shall embrace with the fire of covetessness, whom he shall enflame with the burning desire of lechery."[86] The image, at first glance even innocent, eschews overt sensuality, but the accompanying text addresses the implicit *luxuria* with stern counsel.

Mars & Venus ſurpris par Vulcan.

Sol vid premier Mars & Venus conioints,
Et, lui jalous, à Vulcan les deſcele:
Qui fabriqua des liens ſi bien ioints,
Si treſſubtils, & d'une façon telle
Que Mars fut pris, couché auec la belle,
Pris & lié entre ces ſubtils lacℲ :
Adonq Vulcan tretous les Dieus apelle,
Qui rient fort de ce plaiſant ſoulas.

d 3

The tone has lightened considerably in a later French book illustra-
tion, a woodcut attributed to Bernard Salomon, made for a *Metamorphose figuré,*
published in Lyons in 1557 [FIGURE 37]. Many of the features that would charac-
terize later depictions are now present. Domesticity survives to the extent that
the couple lies on a canopied bed, but the blankets have been abandoned to
expose a nude embrace, as in Wtewael's works a half-century later. The narrative
is condensed but clear, with Mars's armor cast aside, Vulcan having withdrawn
his net, and the other gods, with the help of Apollo's blazing sunshine, inspect-
ing the scene as if through an open window. The accompanying text genially
provides the outlines of the story, concluding that the gods laughed heartily at
this pleasant recreation.

Visual precedents for Wtewael's conception had begun to appear by
the 1530s, especially in the graphic arts. Parmigianino was attracted to the theme

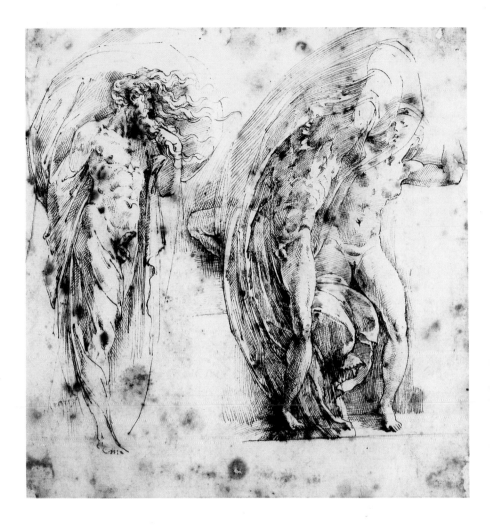

Figure 38
Francesco Mazzuoli,
called Parmigianino
(Italian, 1503–1540).
*Mars and Venus
Surprised by Vulcan*,
1530s. Pen and light
brown ink on paper
spotted with damp, 20 x
19.2 cm (7 ⅞ x 7 ⅝ in.).
Parma, Galleria
Nazionale (510/18).

of Mars, Venus, and Vulcan more than once, and in a drawing that captures
its elemental eroticism, he depicts the crux, Mars and Venus's hopeless entangle-
ment and Vulcan's triumph, signaled by his sexual potency [FIGURE 38]. Fluid
line, intense hatchings, and what A. E. Popham calls an "extremely delicate *stac-
cato* touch"[87] convey a dramatic urgency that is also expressed in windblown
hair, the swirl of the net, and frantic gesture. A certain tension arises from the
figures' separation on the page, for they are intimately bound psychologically

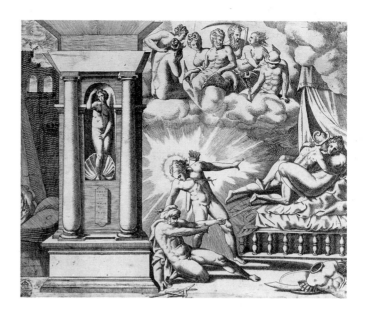

Figure 39
Gian Giacomo
Caraglio (Italian, circa
1500–1565). *Mars
and Venus Surprised
by Vulcan,* circa 1535.
Engraving, 20.7 x 25 cm
(8 ³/₁₆ x 9 ¹³/₁₆ in.).
Dresden, Kupferstich-
kabinett, Staatliche
Kunstsammlungen.

but not by space or setting. Parmigianino develops that tension through contrast—of Vulcan's powerful stance with Mars's unstable, contorted one, and of Mars's angular muscularity with Venus's rounded softness. Nevertheless, Parmigianino has distilled the drama with a characteristic elegance, of elongated form, intricate pose, and graceful design. Wtewael's figures are among his progeny.

Gian Giacomo Caraglio's retelling, in an engraving of about 1535, depicts an earlier moment in the story and is consequently more explicit than Parmigianino's, showing Mars and Venus locked in intimacy [FIGURE 39]. That intimacy will be short-lived, however, for Vulcan, abetted by a brilliant Apollo, is already drawing tight the snare. The discourse is elevated by a formal setting that conflates temple and boudoir, dominated by a niche holding a statue based on the famous Venus de' Medici. The ceiling now is open to the heavens, with the Olympians, including Jupiter, Mercury, Saturn, and four goddesses perched on clouds. With the exception of Diana, who shields her eyes from the painful sight, they look on with none of the amusement imagined by others. Apollo and Vulcan are the heroes, spotlighted by central placement, powerful gestures, and

striking contrast. They are flanked by two images of the goddess of love, the solitary chaste one at the left and the coupled sensual one at the right. Vulcan's struggle becomes a spiritual *exemplum*, enlightened by Apollo's encouragement and inspiration. This interpretation accords with that of sixteenth-century mythographers like Natale Conti, who, in his *Mythologiae,* wrote that "By means of this tale Homer appears to be exhorting men to honor justice, rectitude and integrity, since the gods easily find a way of punishing wrongdoers, however strong and mighty they may be." [88]

By the 1540s, the story of Mars, Venus, and Vulcan had become a subject for paintings. Among the earliest representations in Netherlandish art, and evidently one of the first treatments since antiquity of the theme on a large scale, is Maerten van Heemskerck's panel painting in Vienna, datable between about 1540 and 1545 [FIGURE 40].[89] The figure of Vulcan, in the immediate foreground, is awkwardly truncated, indicating that the panel has probably been

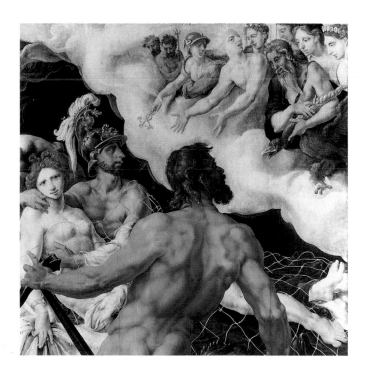

Figure 40
Maerten van Heemskerck (Dutch, 1498–1574). *Mars and Venus Surprised by Vulcan,* 1540–1545. Oil on panel, 96 x 99 cm (37¾ x 39 in.). Vienna, Kunsthistorisches Museum (GG 6395).

cut. The narrative is clear nonetheless. Like Caraglio, Heemskerck fills the heavens with gods and goddesses; indeed, he had been in Italy from 1532 until about 1536 and might have come across Caraglio's engraving, tucking it away for future reference. But, unlike Caraglio, Heemskerck depicts the lovers in relatively chaste embrace, secured by the net. Apollo, here in the heavens, reveals the scene to Jupiter's evident amusement.

Jupiter's jovial reaction should not, however, be taken as condoning the adultery, for on the panel's reverse is a grisaille depicting two cardinal virtues, Prudence and Justice, and a quotation from Proverbs 11:1: "A false balance is abomination to the Lord: but a just weight is his delight."[90] Thus the ancient story is associated with the Christian virtues that it flouted. Heemskerck gave the image even deeper moral significance by associating the scene of illicit physical love with one showing the charity of Thetis, who, on a related panel obtains armor from Vulcan for her adopted son Achilles, whom she had nurtured after he had been rejected by his mother. Personifications of Charity and Temperance originally appeared on the back of this second panel.[91] The discovery of Christian moral *exempla* in pagan themes is characteristic of the Christian humanism of Heemskerck and his Haarlem circle. By contrasting the scandalous scene with an honorable one and by presenting corrective virtues, Heemskerck offers a choice but refrains from preaching. This distinctively Netherlandish modus operandi, formulated in the early sixteenth century, would provide an effective means of moralizing well into the seventeenth century. Wtewael would use it too but instead of presenting clear alternatives would prefer innuendo and ambiguity.

Other artists depicted scenes from the story of Venus, Mars, and Vulcan without a trace of moralizing. In a large, oblong canvas painted about 1552, Jacopo Robusti, called Tintoretto, reinterpreted the myth with novel emphases perhaps based on a contemporary version of the story [FIGURE 41]. With rushing perspective, he plunges us into a room in a Venetian *palazzo,* where we encounter a strange scene: A languid Venus reclines in an ambiguous pose, displaying her nude beauty as she draws a veil around her and turns from her husband, Vulcan. A graybeard who gingerly lifts her drapery, he seems to

Figure 41
Jacopo Tintoretto (Italian, 1518–1594). *Venus, Mars, and Vulcan*, circa 1550–1555. Oil on canvas, 135 x 198 cm (53⅛ x 78 in.). Munich, Alte Pinakothek (9257).

search for evidence of a liaison with Mars. Cupid, Venus's son, sleeps innocently beyond, but the silence is shattered by a yapping little dog who has discovered a visitor hiding under the table—Mars, helmet and all.

Beverly Brown has caught the tone: "The entire scene is staged with the tongue-in-cheek precision of a French farce, in which the actions of the gods are made to resemble the foibles of humanity. The betrayed husband, who peers beneath a scant cloth unlikely to conceal anything, cuts a ridiculous figure, but no more so than the 'heroic' Mars who cowers on all fours."[92] Brown suggests that the painting was commissioned in connection with a Venetian wedding, since Mars and Venus, despite their lack of official status, were frequently associated with marriage, especially in a playful or satirical mode.[93]

While Tintoretto uses the vernacular for this tale of a divine peccadillo, Diego Velázquez juxtaposes celestial and mundane discourse when he

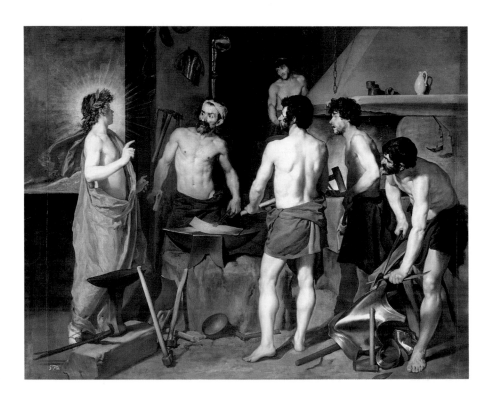

Figure 42
Diego Velázquez
(Spanish, 1599–1660).
*Apollo in the Forge
of Vulcan,* 1630. Oil on
canvas, 223 x 290 cm
(88 x 114 in.). Madrid,
Museo del Prado (1171).

depicts Apollo breaking the news to Vulcan of Venus's infidelity with Mars. In *Apollo in the Forge of Vulcan,* a large canvas of 1630 [FIGURE 42], the sweaty, unshaven armorers, interrupted by a radiant and righteous Apollo, react with slack-jawed astonishment. No doubt his message was cause for surprise, but the apparition itself is so jarring that it, too, seems to justify their incredulity. Like Tintoretto, Velázquez exploits an encounter for comic effect. The unusual choice of scene provided him with a critical moment, a turning point, as dramatic in its way as that of the actual discovery. He realizes it in terms of our own palpable experience. The dusky, littered forge is enlivened with masterly light—the blazing fires, the red-hot metal held poised on the anvil, and Apollo's aureole, which is set against the blue sky of the open window. As god of light, Apollo saw all and thus knew all. Pindar had said of him "He never deceiveth others; and he is not himself deceived by god or man, in deed or counsel." [94] Whenever Apollo plays a role in the dramatization of Mars and Venus's love affair, he implicitly represents truth and righteousness and thus introduces a didactic element. Velázquez, however, tempers that didacticism with humor. Attempts to discover allegorical meaning here have been unsuccessful. [95]

A little over a century later, in the same year, 1754, the theme of Venus, Mars, and Vulcan would engage the imaginations of both François Boucher and John Singleton Copley. The coincidence produced two paintings that contrast as much as the circumstances that produced them. Boucher's large canvas [FIGURE 43] is one of a suite of four devoted to mythological themes and perhaps painted for Madame de Pompadour. [96] Venus, chubby and voluptuous, luxuriates in Mars's embrace, oblivious of the intruder whom her lover has already spied. Vulcan has paused before ensnaring them, his furrowed brow and downcast expression registering the misery of the cuckolded husband. Even the gamboling putti are alert to the tensions of the moment. The boudoir here is a forest glade, furnished with a gilt-bronze perfume-burner, a carved and gilded stool, and a canopied bed, thanks to the putti who hoist aloft a length of coral pink satin. Apollo appears only implicitly, in the heavenly sunshine that illuminates Venus's rosy flesh, and the other Olympians are nowhere to be seen.

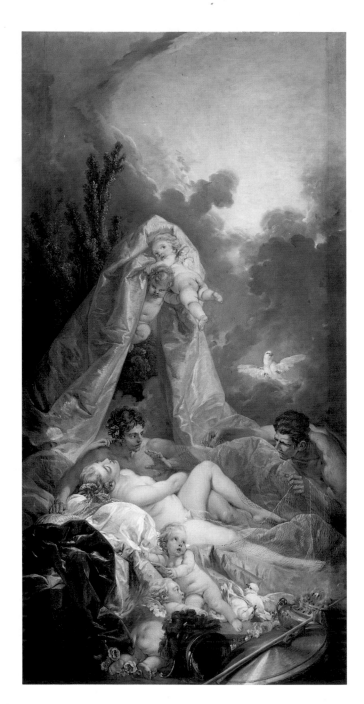

Figure 43
François Boucher
(French, 1703–1770).
*Venus, Mars, and
Vulcan,* 1754. Oil on
canvas, 166 x 85 cm
(65½ x 33⅝ in.). London,
Wallace Collection
(P 438).

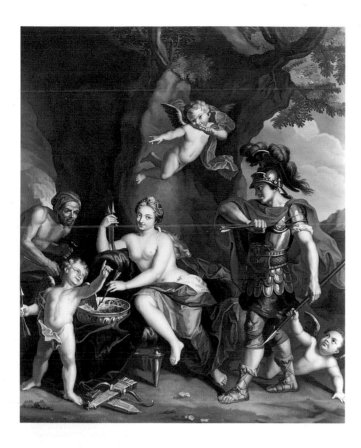

Figure 44
John Singleton Copley
(American, 1738–1815).
The Forge of Vulcan,
1754. Oil on canvas,
76.2 x 63.5 cm
(30 x 25 in.).
Private collection.

Copley was only fifteen or sixteen years old when he took on the challenge of depicting Mars, Venus, and Vulcan, in a canvas now in a private collection [FIGURE 44]. The ambitious young artist was already testing his skill as a portraitist, but here he aspired to what was then regarded as an even higher level of art, namely, history painting, the deeds of deities, saints, heroes, and heroines imaginatively recreated. An autodidact, he learned by copying, using engravings after European paintings for his earliest history pictures. For his *Forge of Vulcan* he turned to an engraving by Nicholas Tardieu after Antoine Coypel.[97] Following his model precisely, Copley, like Boucher, employs an out-door setting, a grotto, where Vulcan works at his forge while admiring Venus, who sits beside him with Cupid nearby. With a mischievous glint in her eye,

Venus dips one of her son's arrows into what is obviously a love potion. Mars, already smitten, grasps the provocative arrow as he approaches her. One of Cupid's companions, in flight above the lovers, abets the deception by cautioning secrecy, while another relieves Mars of his spear, urging him to make love, not war. Rather than a narrative, this is an allegory of duplicitous love, instigated by Venus. It is presented, however, with good humor and no evident moralizing. Without knowing more about the range of engraved models available to Copley, we can only speculate about his motivation for the choice of this subject. In any case, it reveals a side of his character that does not surface in the portrayal of his Bostonian sitters.

Honoré Daumier can have the last word. In an illustration from his *Histoire ancienne,* published in *Le Charivari* on November 27, 1842, he invites us to share the Olympians' laughter [FIGURE 45], ruefully observing that it has been "reserved for unhappy husbands ever since." The publication of Daumier's series was a salvo in the battle between the "ancients" and the "moderns," waged in France from the seventeenth into the nineteenth century. On December 22, 1841, *Le Charivari* introduced the *Histoire ancienne* with the facetious announcement that Daumier had just returned from a sketching trip to Greece. At the end of the series, it was proclaimed that "whereas David had glimpsed the beauty of antiquity, and Ingres had sought it, Daumier had found it." Daumier thus lampoons the high seriousness with which his contemporaries approached—and often misinterpreted—antiquity.[98]

When Wtewael's Getty *Mars and Venus Surprised by Vulcan* is seen among these illustrations of the tale, some distinctive features emerge. His conception is exceptionally dynamic, built on diagonal lines of force and extending into fictive depth as well as into our own actual space via the direct gazes of Cupid and Diana. He captures the climactic moment only to place it in a spatial and temporal continuum, already exploring dramatic and pictorial devices that others would develop in the years to come. A century and a half later, Boucher would still employ a similar formal vocabulary, narrowing the dramatic focus and elaborating on its sensuality to suit French courtly tastes [FIGURE 43]. Parmigianino, too, depicts only the gist and distills the erotic essence in his extra-

MARS ET VENUS.

ordinary drawing [FIGURE 38]. In contrast, Tintoretto develops the narrative to give the myth an idiosyncratic twist [FIGURE 41]. Wtewael, following Goltzius, presents the full *dramatis personae,* with an economy missing in the more deliberate simultaneous narratives of antiquity and the Renaissance [FIGURES 34 *and* 35] but quite faithful to the ancient texts.

Wtewael's is, of course, the only small painting on copper, with a jewel-like precision that goes beyond even that of the illumination in Christine de Pisan's *Epitre d'Othéa* [FIGURE 36]. His meticulous technique is ideally suited to the presentation of eros and didacticism side by side, for it imbues them with equal plausibility. This is essential to the teasing equivocation that engages both the gaze and the higher mind. In Heemskerck's ambitious depiction [FIGURE 40], the erotic valence is weaker and the didacticism more specific. Goltzius intensifies the eroticism but retains an explicit didacticism in the engraving's accompanying text. Wtewael heightens the sensual and mutes the didactic. While his eroticism is no more explicit than that in several other images we have seen, its sheer physicality is compelling.

VICISSITUDES

Art with sexual imagery is as old, and as new, as art itself. A rock engraving possibly made as early as 15,000 B.C. appears to depict a copulating couple, the earliest such image yet discovered.[99] Jeff Koons explored the same subject matter in an exhibition in New York in 1991.[100] Wtewael's *Mars and Venus Surprised by Vulcan* thus belongs to a continuum of images with sexual subjects that began in prehistory. Our own reactions to them spring from a deep stratum of experience, and no matter what the religious, mystical, or other social function of these images in their generating cultures was, they speak to us with a powerful voice, communicating on an elemental human level. That voice has, however, often been suppressed, by moral, religious, and other cultural forces.

The fortunes of Wtewael's depictions of Mars, Venus, and Vulcan reflect our complex and often ambivalent reactions to sexual imagery. We know nothing of the earliest life of Wtewael's two extant paintings. Even if the one now in the Mauritshuis was originally owned by Jan van Weely or Melchior Wijntgis, in the absence of inventories, journals, or other firsthand reports, we do not know how or where Wijntgis or Van Weely exhibited it. We do, however, know how the pictures fared in more recent times. By 1763, the painting now in the Mauritshuis had been acquired by Willem V, Prince of Orange, at Het Loo; it is number 147 in an inventory made in that year. When the Mauritshuis opened as a museum on January 1, 1822, over one hundred paintings from the House of Orange, including Wtewael's *Mars and Venus Surprised by Vulcan,* formed the basis of the collection. Wtewael's painting has not, however, always been proudly exhibited. In the 1920s, C. M. A. A. Lindeman found it in the storeroom when he was researching his monograph on the artist. He wrote that on the basis of its outstanding quality, the painting surely deserved a better place, but the subject relegated it to storage, "to protect an immature public from itself."[101] Lindeman did not illustrate the painting, either for want of a photograph or in order to protect the innocent. It was still in storage, covered

with yellowed varnish, when I came to study it in 1971 for my own monograph on Wtewael. In 1983, however, after the Getty Museum had acquired its *Mars and Venus Surprised by Vulcan,* the painting was restored. While the Mauritshuis was being renovated, it was included in a traveling exhibition of "masterpieces" from the collection, and it is now exhibited in The Hague.[102]

The Getty painting was acquired by Count Alexander Sergejewitsch Stroganoff in St. Petersburg before 1807. By then, the picture had been given a companion piece: The little copper had a hinged cover formed by another painting, a *Violinist* attributed to Gerrit Berckheyde.[103] That arrangement existed when the Stroganoff pictures were sold at auction in Paris in 1924,[104] and a later owner, the New York collector Jules Bache, preserved it. Indeed, the odd pairing survived as late as 1945, when his collection was dispersed.[105] Thus the innocuous, and mediocre, musician screened the scene of illicit love from all but the privileged. By the time the painting had come into the hands of another private collector, where I first saw it in 1972, it had been separated from its protective *Violinist* but was then inserted into a fine leather binder and kept on a bookshelf, again available only to the cognoscenti. This special treatment no doubt contributed to the painting's excellent condition.

Alas, Wtewael's drawings of the subject were also given "special treatment," but it was destructive. As we have seen, his two preparatory studies were censored, through the excision of the nude bodies of Mars and Venus [FIGURES 19 AND 20]. They are not the only works by Wtewael to have been bowdlerized. In three depictions of the wedding of Peleus and Thetis (New York, Saul P. Steinberg; Nancy, Musée des Beaux-Arts; and Williamstown, Sterling and Francine Clark Art Institute [FIGURE 46]), an aroused satyr was provided with a loin cloth by a later hand.[106] Nymphs and goddesses whom Wtewael had painted nude acquired draperies, now removed, in a *Venus and Adonis* (Germany, Hohenbuchau Collection) and a *Judgment of Paris* (Cleveland Museum of Art).[107]

The history of Western art abounds with such instances of censorship, on works in every medium, of both modest and major importance.[108] Until recently, the Virgin in the Van Orly *Holy Family,* in the Getty Museum

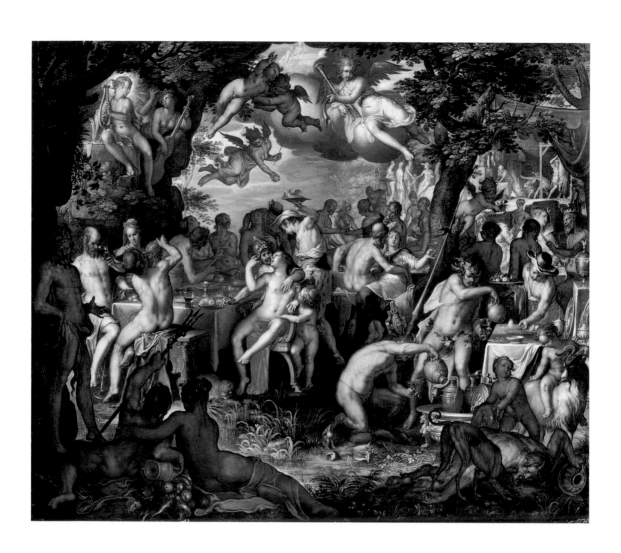

[FIGURE 30], had worn a low-necked but decorous gown, which, in a recent restoration, was returned to its original state.[109] Overpaint was removed to reveal her breast, now emphasized not only by virtue of its central placement in the picture but also by Christ's embracing gesture. The Madonna is once again an iconic *Maria lactans,* attesting to the truth of the Incarnation, now defying the scruples of those who had seen immodesty instead of theology.[110]

One of the more notorious cases of censorship involves Michelangelo's *Last Judgment* in the Sistine Chapel, completed in 1541. The issue remains alive, affecting decisions made during the fresco's recent restoration. The significance of Michelangelo's nudes, in their elemental state before God, was lost on many of his contemporaries. From the outset there were charges of obscenity and indecorum. Even Pietro Aretino, whose own works are among the most licentious of the time, complained after seeing the completed fresco that it "would be appropriate in a voluptuous whorehouse, not in a supreme choir."[111] Ten years after the fresco had been unveiled, the influential preacher Ambrogio Politi, known as Caterino, virulently attacked the nudity in the fresco, associating it with heresy. The forces of the Counter Reformation gathered momentum, and at the last session of the Council of Trent, in 1564, it was determined that the offending nudes should be retouched. The unenviable task fell to Michelangelo's friend and admirer Daniele da Volterra, who began work shortly after the master's death and soon became known as *"il braghettone,"* the britches-maker. This was only the first of several cover-up campaigns; in all, some thirty-six figures were ultimately amended.[112] The recently completed cleaning and restoration have not, however, returned the fresco to its original condition. Bits of what have been called "lingerie" remain.[113]

Other artists' depictions of Mars and Venus surprised by Vulcan suffered alterations like those inflicted on Wtewael's drawings. In a drawing by Parmigianino (London, British Museum), the bodies of the couple have been totally obliterated, so that Vulcan drags a reluctant, chaste Diana forward to witness what is now an empty bed.[114] The first state of an engraving by Enea Vico, after Parmigianino, showed Mars and Venus in voluptuous embrace, with Vulcan at his forge nearby [FIGURE 47]. The plate was altered sometime later, perhaps

Figure 46
Joachim Wtewael.
*The Wedding of Peleus
and Thetis,* 1612. Oil
on copper, 36.5 x 42 cm
(14 ⅜ x 16½ in.).
Williamstown, Sterling
and Francine Clark
Art Institute (1991.9).

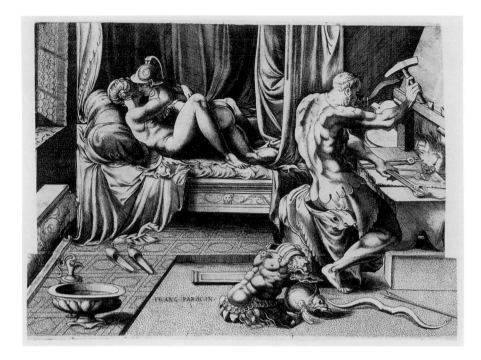

Figure 47

Enea Vico (Italian, active 1541–1567) after Parmigianino. *Mars, Venus, and Vulcan,* 1543. Engraving, 1st state, 22.7 x 34 cm (8¹⁵⁄₁₆ x 13⅜ in.). New York, Metropolitan Museum of Art, The Elisha Whittelsey Collection, The Elisha Whittelsey Fund, 1949 (49.97.351).

by an unskilled craftsman in the seventeenth century, who replaced the amorous couple with a still voluptuous but now draped Venus, sleeping alone as her husband hammers out the now meaningless chain [FIGURE 48].[115]

The sequestering and expurgation of Wtewael's scenes of Mars, Venus, and Vulcan recall reactions to the discovery of erotica at Pompeii. Soon after a small marble statue of a satyr copulating with a goat was unearthed about 1758, it was made inaccessible. By 1786, however, the piece was described as "kept concealed in the Royal Museum of Portici," but it was nevertheless well known, having obviously been available to those in the know.[116] Two centuries later, a proper gentleman who would tip the custodian could be admitted to the locked chamber where such items resided, still concealed from delicate gazes.[117] When the sequestered collection of Pompeian erotica in the Museo Nazionale in Naples was published for a select audience in the 1870s, in the eighth and final volume of M. L. Barré's catalogue, propriety reigned. Barré explained,

Figure 48
Enea Vico after Parmigianino. *Venus and Vulcan.* Engraving, late state, 22.7 x 34 cm (8¹⁵⁄₁₆ x 13⅜ in.). New York, Metropolitan Museum of Art, Purchase, Joseph Pulitzer Bequest, 1917 (17.50.16–139).

> Our draftsmen have obeyed an analogous rule [fig leaves]; but instead of tacking on draperies or other accessories to their designs—which might have spoiled the spirit of the composition or distorted the thought of the ancient artist— they have restricted themselves to miniaturizing a few things. The truly erotic nudity of these rare subjects has thereby been stripped of the excessively crude and impertinent features that marked the originals. They have lost their importance; sometimes, without detriment, they have utterly vanished.[118]

The strategically placed patches of fog, in lieu of fig leaves, served the same function as the excisions in Wtewael's two drawings.

Now, a century and a quarter later, there is unprecedented freedom of expression in the arts, and artifacts of great importance in shaping interpretations of past cultures have been reclaimed for scholarship. A notable instance is the

disbanding of the *Museum Secretum* in the British Museum, to which objects had long been consigned solely on the basis of what had been considered "obscene" subject matter, all other considerations aside. The objects that had been kept there for about one hundred years, until the early twentieth century, have now for the most part been distributed among the appropriate departments. Even as such systems of segregation are abandoned, permitting readier access, the consequences of decades of suppression have yet to be overcome. Catalogues of collections made in the past are often incomplete, so that the very existence of many objects with sexual subjects is unknown.[119] Rediscovering them is the first step. The task of reintegrating them into their cultural matrices will require an objectivity, not possible in more repressive times, of which we are now perhaps capable.[120]

The culture clashes engendered by provocative material have hardly evaporated. The debate over the National Endowment for the Arts's funding of controversial exhibitions such as the retrospective "Robert Mapplethorpe: The Perfect Moment" reveals the persistence and power of such conflicts.[121] That exhibition's opening at the Contemporary Arts Center in Cincinnati resulted in the first criminal case brought against an American museum for the contents of an exhibition, with director Dennis Barrie and the museum indicted with "pandering obscenity." Whether or not the Mapplethorpe photographs were art was the primary issue in the trial. The decision to acquit validated a concept of art as embracing human experience in all its multiplicity.[122]

Wtewael's fortunes reflect this climate. His reputation has flourished in the last decade, which bespeaks a new public acceptance of the pervasive erotic currents in his work. Since 1981, major American museums have acquired, and prominently display, such paintings as his *Lot and His Daughters* [FIGURE 26], the *Wedding of Peleus and Thetis* [FIGURE 46], and *The Martyrdom of Saint Sebastian* [FIGURE 49].[123] The Metropolitan Museum of Art in New York exhibited his *Golden Age,* of 1605, promptly upon purchasing it in 1993.[124] Acquired by the Getty Museum ten years earlier, Wtewael's *Mars and Venus Surprised by Vulcan* has been released into public galleries from its earlier confinement behind another painting or on a bookshelf. This book has been written to present it to an even wider audience.

NOTES

1 *Metamorphoses,* trans. F. J. Miller, vol. 3, pt. 1 of *Ovid in Six Volumes,* The Loeb Classical Library (Cambridge, 1977), p. 191. Ovid also relates the tale, with slight variations, in *Ars amatoria,* trans. J. H. Mozley, vol. 2 of *Ovid in Six Volumes,* The Loeb Classical Library (Cambridge, 1979), pp. 105–107. Both accounts are derived from Homer's in the *Odyssey* 8.266–366. All are discussed in chapter three.

2 See A. W. Lowenthal, *Joachim Wtewael and Dutch Mannerism* (Doornspijk, 1986), pp. 94–96, A-15. The name is pronounced approximately "oo-te-val."

3 See Lowenthal (note 2), pp. 117–118, A-44.

4 Museum catalogue records, citing opinions of Adolph Loewi (October 19, 1948) and John Hayward (letter, September 25, 1974).

5 For other examples of *pronk* still lifes with ewers, see S. Segal, *A Prosperous Past: The Sumptuous Still Life in The Netherlands, 1600–1750,* ed. W. B. Jordan, exh. cat. (Stedelijk Museum Het Prinsenhof, Delft; Fogg Art Museum, Harvard University, Cambridge; and Kimbell Art Museum, Fort Worth, Texas, 1988), p. 151, no. 40 (by Jan Davidsz. de Heem), p. 158, no. 43 (by Pieter de Ring), and p. 178, no. 53 (by Willem Kalf).

6 The first cross-bladed shears with a center pivot are datable to the first century A.D. Examples of long-bladed scissors like those Wtewael shows survive from the sixteenth century. Both are illustrated in *A Story of Shears and Scissors, Their Origin and Growth in the Old World and the New . . .* ([Newark, N.J.,] 1948), n.p.

7 See Lowenthal (note 2), p. 99, A-19.

8 See the portrait by Wybrand de Geest of Sophia van Vervou, dated 1632 (Van Harinxma thoe Slooten Stichting), in E. de Jongh, *Portretten van echt en trouw: Huwelijk en gezin in de Nederlandse kunst van de zeventiende eeuw,* exh. cat. (Frans Halsmuseum, Haarlem, 1986), pp. 141–144, no. 24.

9 Concerning style and date, see Y. Hackenbroch, *Renaissance Jewellery* (London, 1979), pp. 103–104, fig. 265, color plate X.

10 On other small garnitures of the period, see O. Gamber, "Armour Made in the Royal Workshops at Greenwich: Style and Construction," *The Scottish Art Review* 12, 2 (1969), pp. 1–13, 30, esp. p. 13 and pl. 27 (concerning a small French garniture of field armor made for Sir Henry Lee about 1585).

11 S. Jervis, *Printed Furniture Designs before 1650* ([London,] 1974), pp. 38–39.

12 First published in Utrecht in 1621 (ibid., p. 41). De Passe's designs repeat structural and decorative features found in earlier books like Hans Vredeman de Vries's *Variae Architecturae Formae . . . ,* probably from 1588 (ibid., p. 29, figs. 153–154), which also could have contributed to Wtewael's conception.

13 Paul was the son of Hans, mentioned in the preceding note. Compare the sphinxes on the headboard of a bed in plate 9 of Paul Vredeman de Vries's *Verscheyden Schrynwerck* (Amsterdam, 1630).

14 It is not clear how the curtains were hung. The bed has been much restored.

15 On the drawing's function and date, see F. Anzelewski, *Dürer and His Time,* exh. cat. (National Gallery of Art, Washington, D.C., 1967), pp. 81–82, no. 80.

16 For more on copper as a support, see
 K. Andrews, *Adam Elsheimer: Paintings,
 Drawings, Prints* (New York, 1977),
 pp. 169–170.

17 The support has only one slightly bent edge
 in the upper right corner, which has been
 retouched. There are some very small retouch-
 ings on the headboard, in the green drapery
 above, and in the dark cloud at the top. There
 is some slight oxidation in the darks of the
 blue drapery. Two little holes at the upper
 edge, from which the painting was once hung,
 have been filled.

18 See Lowenthal (note 2), pp. 97–99, A-18.

19. For more on the significance of shoes and
 slippers, see Lowenthal (note 2), p. 120.

20 Unless otherwise noted, all translations from
 Dutch are mine.

21 See M. A. Schenkeveld, *Dutch Literature
 in the Age of Rembrandt: Themes and Ideas*
 (Philadelphia, 1991), pp. 52, 77–78, 85–86,
 130–133. For a judicious assessment of the
 relationship between painted motifs and
 emblems, see L. O. Goedde, *Tempest and
 Shipwreck in Dutch and Flemish Art: Conven-
 tion, Rhetoric, and Interpretation* (University
 Park, Pa., 1989), pp. 10–15.

22 "Home, then, was both a microcosm, and a
 permitting condition, of the properly gov-
 erned commonwealth," says S. Schama, *The
 Embarrassment of Riches: An Interpretation of
 Dutch Culture in the Golden Age* (New York,
 1987), p. 386. For more on Dutch family life
 and households, see Schama's chapter six,
 "Housewives and Hussies: Homeliness and
 Worldliness," pp. 375–480.

23 B. Hulsius, *Emblemata sacra . . .* (n.p., 1631),
 pp. 100–104; see E. de Jongh et al., *Tot lering
 en vermaak*, exh. cat. (Rijksmuseum, Amster-
 dam, 1976), p. 195.

24 See S. Segal, *A Fruitful Past: A Survey of the
 Fruit Still Lifes of the Northern and Southern
 Netherlands from Brueghel till Van Gogh*,
 exh. cat. (Gallery P. de Boer, Amsterdam,
 and Herzog Anton Ulrich-Museum, Braun-
 schweig, 1983), p. 51. Segal speaks of knives
 and swords; I suggest the imagery be extended
 to shears.

25 D. V. Coornhert, *Zedekunst, dat is, wellevens-
 kunste*, edited and annotated by B. Becker
 (Leiden, 1942; based on 1586 ed.), p. 31.

26 J. Cats, "Houwelick" (Marriage), in *Alle de
 wercken* (Amsterdam, 1665), p. 162. For more
 on seventeenth-century ideas about the
 power and dangers of "Sight," particularly
 concerning depictions of female nudes, see
 E. J. Sluijter, "Venus, Visus en Pictura,"
 in *Goltzius-Studies: Hendrick Goltzius
 (1558–1617)*, Nederlands Kunsthistorisch
 Jaarboek 42–43 (1991–1992) (Zwolle, 1993),
 pp. 337–396; English summary, pp. 395–396.

27 H. J. Jensen, *The Muses' Concord: Literature,
 Music, and the Visual Arts in the Baroque
 Age* (Bloomington, Ind., 1976), pp. 15–18,
 and chapter four, "Rhetorical Theory and the
 Arts," esp. pp. 66–68.

28 See Lowenthal (note 2), pp. 119–120, A-45.

29 C. van Mander, "Het leven der doorluchtighe
 Nederlandtsche en Hoogh-duytsche
 schilders," in *Het Schilder-Boeck* (Haarlem,
 1604), fol. 280r (in the biography of Cornelis
 Ketel).

30 C. van Mander, "Wtlegghingh op den Meta-
 morphosis pub. Ovidij Nasonis (Explanation
 of the Metamorphoses of Publius Ovidius
 Naso)," in *Het Schilder-Boeck* (note 29), fols.
 39r–39v.

31 Ibid., fol. 15v.

32 Quoted more extensively by Schama (note
 22), p. 398. For more on Cats's "Houwelijck,"
 see D. R. Smith, *Masks of Wedlock: Seven-
 teenth-Century Dutch Marriage Portraiture*
 (Ann Arbor, Mich., 1982), pp. 26–27, 31–32,
 45–46, 67–68, 162.

33 J. Ray, *Observations . . . in a Journey through . . . the Low Countries* (London, 1673), p. 55.

34 Schama (note 22), pp. 423–424.

35 A. T. van Deursen, *Plain Lives in a Golden Age: Popular Culture, Religion, and Society in Seventeenth-Century Holland,* trans. M. Ultee (Cambridge, 1991), pp. 89–90.

36 Schama (note 22), pp. 405–406, and Van Deursen (note 35), p. 92.

37 Schama (note 22), pp. 467–474, and Van Deursen (note 35), pp. 97–98.

38 Offered for sale at Christie's, Amsterdam, November 12, 1990, lot 54. Another drawing, in Leiden (Kunsthistorisch Instituut der Rijksuniversiteit, Prentenkabinet [PK 6866]), corresponds to the figures at the top of this preparatory sketch. I previously accepted the Leiden sheet as a study by Wtewael (see Lowenthal [note 2], p. 118), but I now prefer to call it a copy.

39 Pen and gray-brown ink with gray wash, 33.5 × 23 cm (13³⁄₁₆ × 9 in.). St. Louis, City Art Museum (126.66). See Lowenthal (note 2), pl. 61.

40 Van Mander (note 29), fols. 296v–297r.

41 E. K. J. Reznicek, *Die Zeichnungen von Hendrick Goltzius,* trans. I. Jost (Utrecht, 1961), vol. 1, pp. 119, 373, nos. 293, 294.

42 Van Mander (note 29), fols. 275r and v. On Wijntgis and Van Weely, see also G. Luijten et al., eds., *Dawn of the Golden Age: Northern Netherlandish Art 1580–1620,* exh. cat. (Rijksmuseum, Amsterdam, 1993), pp. 147–149, 161–162.

43 Van Mander (note 29), fol. 293r.

44 Anonymous biography of Van Mander in the 1618 edition of the *Schilder-Boeck* (n.p.). See C. van Mander, *Dutch and Flemish Painters,* trans. C. van de Wall (1936; reprint, New York, 1969), p. LVII.

45 Van Mander (note 29), fols. 209v, 246v. Van Mander also noted the following in Wijntgis's collection: a *Saint Jerome* by Lodewijck Jans van den Bos (fol. 217r); three works by Joachim Patinir (fol. 219r); three landscapes and a *Lot and His Daughters* by Herri met de Bles (fol. 219v); a *Lucretia* by Jan Gossaert (fol. 225v); a *Madonna* by Joos van Cleve with a landscape by Patinir (fol. 227r); an *Adam and Eve,* a *Caritas,* and a *Crucifixion* by Jacob de Backer (fol. 232r); a kitchen piece with life-size figures and an *Entry into Jerusalem* by Joachim Beuckelaer (fol. 238v); *Nine Sleeping Muses* by Frans Floris (fol. 242r); a large landscape with peasants by Gillis Mostaert (fol. 261v); a money-collector in his office by Marinus van Roemerswaele (fol. 261v); a *Pyneas* with life-size figures by Joos van Winghen (fols. 264v); three works by Gillis van Coninxloo (fol. 268r); and a *Zeuxis* by Otto van Veen (fol. 295r).

46 See H. Hymans, *Près de 700 biographies d'artistes Belges,* vol. 2 of *Oeuvres de Henri Hymans* (Brussels, 1920), pp. 737–749.

47 *Karel van Mander, Den grondt der edel vry schilder-const,* translation and commentary by H. Miedema (Utrecht, 1973), vol. 1, pp. 34–37. Miedema further discusses Wijntgis in vol. 2, p. 324.

48 For more on patronage of the Dutch mannerists, see Lowenthal (note 2), pp. 21–24, 32, 54–55, 63–64.

49 T. D. Kaufmann, "Eros et poesia: la peinture à la cour de Rodolphe II," *Revue de l'Art* 69 (1985), pp. 32–33.

50 Van Mander (note 29), fols. 296v, 297r. See also Lowenthal (note 2), pp. 25–37.

51 Van Mander (note 29), fol. 284r (in the biography of Goltzius). Spranger's *Mary Magdalen* (Besançon, Musée des Beaux-Arts et d'Archéologie [D 282]), was evidently among those brought to Haarlem, since it served as the model for an engraving

by Goltzius of 1585. See Lowenthal (note 2), figs. 2, 3.

52 See W. L. Strauss, ed., *Hendrik Goltzius, 1558 1617: The Complete Engravings and Woodcuts* (New York, 1977), vol. 1, nos. 217–220.

53 On this period, see A. W. Lowenthal, "The Disgracers: Four Sinners in One Act," in *Essays in Northern European Art Presented to Egbert Haverkamp-Begemann on His Sixtieth Birthday* (Doornspijk, 1983), pp. 148–153.

54 *The Illustrated Bartsch,* vol. 4, *Netherlandish Artists,* ed. W. Strauss (New York, 1980), p. 497, 64. See Lowenthal (note 2), fig. 83.

55 Compare Cornelis's *Tityus,* of 1588 (Vienna, Graphische Sammlung Albertina), which Muller copied (Brussels, Musée des Beaux-Arts [2664]). For Cornelis's drawing, see P. J. J. van Thiel, "Cornelis Cornelisz van Haarlem as a Draughtsman," *Master Drawings* 3, 2 (1965), pl. 2.

56 See Lowenthal (note 2), pp. 39–40.

57 See Lowenthal (note 2), pp. 91–92, A-13. The Los Angeles painting is in my opinion a replica, that is, another version by Wtewael, of the painting published by I. Sokolova, "A New Acquisition by the Hermitage Museum: Joachim Wtewael's *Lot and His Daughters,*" *Burlington Magazine* 133 (September 1991), pp. 619–622. See also Luijten (note 42), pp. 557–558, no. 229 (where the Los Angeles painting is called a studio replica).

58 Strauss (note 52), vol. 2, pp. 618–619, no. 336.

59 For further discussion, see A. W. Lowenthal, "Lot and His Daughters as Moral Dilemma," in *The Age of Rembrandt: Studies in Seventeenth-Century Dutch Painting,* Papers in Art History from The Pennsylvania State University 3 (n.p., 1988), pp. 13–27.

60 Van Mander (note 29), fol. 296v.

61 See Lowenthal (note 2), pp. 126–127, A-53.

62 B. Broos (*Meesterwerken in het Mauritshuis,* exh. cat. [Mauritshuis, The Hague, 1987], p. 418), writes that I date the Getty painting earlier than the one in The Hague, which I indeed had in "The Paintings of Joachim Anthonisz. Wtewael (1566–1638)" (Ph.D. diss., Columbia University, 1975), pp. 192–197. Broos believes that both paintings predate 1604. B. B. Fredericksen (*Masterpieces of Painting in the J. Paul Getty Museum,* rev. ed. [Malibu, 1988], no. 17), evidently following Broos, also dates the picture about 1604. If my suggested date of about 1610 for the Getty painting is correct, Wtewael must have painted still another as yet unidentified version of the subject before 1604, since Van Mander mentions two. Perhaps the missing picture is the small oval copper (13 × 10 cm), formerly in the collection of K. Glaser, Berlin (see C. M. A. A. Lindeman, *Joachim Anthonisz. Wtewael* [Utrecht, 1929], p. 252) and evidently sold in Berlin at the Internationales Kunsthaus, May 9, 1933, lot 244 (see Lowenthal [note 2], p. 215).

63 Panel, 44.5 × 66 cm (17½ × 26 in.). Washington, D.C., National Gallery of Art (2610). See Lowenthal (note 2), pp. 151–152, A-88, pl. 122 and color pl. XXII.

64 Concerning the genesis of the mannerist style in the North, see A. W. Lowenthal, *Netherlandish Mannerism in British Collections,* exh. cat. (Entwistle Gallery, London, 1990), pp. 9–32.

65 Small bronzes and plaster casts of Michelangelo's figures were available in the Netherlands. See Van Thiel (note 55), p. 128.

66 For more on the altarpiece, see S. J. Freedberg, *Painting in Italy, 1500 to 1600* (Baltimore, 1971), pp. 118–119, pl. 71.

67 Another version in the Musées royaux des Beaux-Arts de Belgique in Brussels (4160) has been placed in the circle of Jan Gossaert.

68 Peter Fusco, Curator of Sculpture, attributes the piece to Mont on the basis of comparison

with a documented work illustrated in L. O. Larsson, "Bildhauerkunst und Plastik am Hofe Kaiser Rudolfs II," *Leids Kunsthistorisch Jaarboek* (1982), p. 215, figs. 4, 5.

69 See the compendium of literary and visual treatments in J. D. Reid, *The Oxford Guide to Classical Mythology in the Arts, 1300–1900s* (New York, 1993), vol. 1, pp. 195–203.

70 The following is based on and quotes *The Odyssey of Homer,* trans. R. Lattimore (New York, 1967), pp. 128–130.

71 On Homer's moral code, see L. A. Post, "The Pattern of Success: Homer's Odyssey," in *From Homer to Menander: Forces in Greek Poetic Fiction* (Berkeley, 1951), pp. 12–26.

72 Ovid, *Metamorphoses* (note 1), p. 181.

73 Ibid., p. 191.

74 Ovid, *Ars amatoria* (note 1), p. 105.

75 On the role of the *Ars amatoria* in Ovid's banishment, see R. Syme, *History in Ovid* (Oxford, 1978), pp. 221–222, 229.

76 *Lexicon Iconographicum Mythologiae Classicae* (LIMC), vol. II, pt. 1 (Munich, 1984), p. 126.

77 C. Robert, *Die antiken Sarkophag-Reliefs,* vol. 3, pt. 2 (Berlin, 1904), pp. 237–241, nos. 193–195, pls. LXII, LXIIa (now in the Amalfi Cathedral; the Palazzo Albani, Rome; and the Museo dell'Abbazia Greca, Grottaferrata [see note 78]).

78 J. Winckelmann, *Monumenti antichi inediti . . . ,* 2nd ed., vol. 1 (Rome, 1821), no. 27. Reproduced by Robert (note 77), no. 195″, and described as lost. Despite differences in proportions, this and the other two drawings reproduced in Robert's nos. 195 and 195′ seem to record the sarcophagus now in the Museo dell'Abbazia Greca, Grottaferrata. See H. Sichtermann and G. Koch, *Griechische Mythen auf römischen Sarkophagen* (Tübingen, 1975), p. 24, pls. 26, 29.

79 Sichtermann and Koch (note 78), p. 24. Winckelmann misinterpreted it as a crook.

80 Thus identified by Sichtermann and Koch (note 78), who suggest that the damaged arms probably originally carried a horn filled with opium and a poppy stalk. That area in the engraving is Winckelmann's reconstruction.

81 E. Wind, *Pagan Mysteries in the Renaissance* (London, 1958), pp. 81–84 (citing Horace, Ovid, Lucan, and Petrarch), and E. Panofsky, *Studies in Iconology: Humanistic Themes in the Art of the Renaissance* (Oxford, 1939), pp. 163–164.

82 F. Cumont, *Recherches sur le symbolisme funéraire des Romains* (1942; reprint, New York, 1975), pp. 20–22.

83 C. G. Lord, "Some Ovidian Themes in Italian Renaissance Art" (Ph.D. diss., Columbia University, 1968), p. 103, fig. 43.

84 Concerning the date, see S. L. Hindman, *Christine de Pizan's "Epistre d'Othéa": Painting and Politics at the Court of Charles VI* (Toronto, 1986), pp. 17–18.

85 Ibid., p. xx. Hindman's thesis is that the *Epitre* is an allegory urging the practice of wise politics.

86 Adapted from *The Epistle of Othea to Hector or The Boke of Knyghthode,* trans. S. Scrope (London, 1904), pp. 61–62, no. LVI.

87 A. E. Popham, *Catalogue of the Drawings of Parmigianino,* vol. 1 (New Haven, Conn., 1971), p. 28.

88 N. Conti, *Mythologiae* (Venice, 1568), p. 47 (as cited by I. M. Veldman, *Maarten van Heemskerck and Dutch Humanism in the Sixteenth Century,* trans. M. Hoyle [Maarssen, 1977], p. 39).

89 Concerning the date, see Veldman (note 88), pp. 34–36. See also R. Grosshans, *Maerten van Heemskerck: Die Gemälde* (Berlin, 1980), pp. 124–125, no. 22, figs. 24–25.

90 See Grosshans (note 89), fig. 25.

91 Ibid., pp. 125–126, no. 23, fig. 26.

92 B. L. Brown and A. K. Wheelock, Jr., *Master-works from Munich: Sixteenth- to Eighteenth-Century Paintings from the Alte Pinakothek*, exh. cat. (National Gallery of Art, Washington, D.C., 1988), p. 69.

93 Ibid., p. 70.

94 Pythian Odes III.28. *The Odes of Pindar*, trans. Sir J. Sandys, The Loeb Classical Library (Cambridge, 1978), pp. 186–187.

95. J. Brown, *Velázquez, Painter and Courtier* (New Haven, Conn., 1986), pp. 74, 289, n. 16, and E. Harris, *Velazquez* (Oxford, 1982), p. 80.

96 J. Ingamells, *The Wallace Collection Catalogue of Pictures*, vol. 3, *French before 1815* (London, 1989), pp. 49–52.

97. J. D. Prown and P. Welch, "A Note on Copley's *Forge of Vulcan*," *The Art Quarterly* 33, 2 (1970), pp. 176–178. I thank Carrie Rebora for this reference.

98 M. Cieri et al., eds., *Honoré Daumier: Histoire ancienne*, exh. cat. (J. Paul Getty Museum, Malibu, 1975), pp. vi–vii.

99 R. Begoen and J. Clottes, "Un cas d'erotisme prehistorique," *La Recherche* 15, 157 (July–August 1984), pp. 992–995, ill.

100 The exhibition, at the Sonnabend Gallery in December 1991, was called "Made in Heaven." See C. Ratcliff, "Not for Repro," *Artforum* (February 1992), pp. 82–85.

101 Lindeman (note 62), p. 70.

102 Broos (note 62), pp. 417–420. The Wtewael was featured in B. Broos and R. van Leeuwen, *Twee decennia Mauritshuis: Ter herinnering aan Hans R. Hoetink, directeur 1972–1991* (Zwolle, 1991), pp. 42–43, fig. 6. It was Hoetink who rescued the painting from storage.

103 So described in the text accompanying engravings by Karl Iwanowitsch Kollmann in *Collection d'estampes d'après quelques tableaux de la Galerie de . . . Comte A. Stroganoff* (St. Peters-

burg, 1807)(cited by Lindeman [note 62], p. 71, n. 1). The *Mars and Venus Surprised by Vulcan* was not among the compositions that were engraved. I am grateful to Helen Mules, Alexei Larionov, and Vadim Sadkov for help in confirming the *Collection d'estampes* reference.

104 Stroganoff sale, Galerie Georges Petit, Paris, May 22, 1924, lot 1.

105. Bache sale, Kende Galleries at Gimbel Bros., April 23, 1945, lots 3 and 4.

106 For the New York and Nancy paintings, see Lowenthal (note 2), pp. 123–124, A-49 and A-50, figs. 70, 71, color pl. xv.

107 For the *Venus and Adonis*, see Lowenthal (note 2), p. 122, A-47, pl. 66 and color pl. XIV; for the *Judgment of Paris*, ibid., p. 101, A-21, pl. 32.

108 J. Clapp, *Art Censorship: A Chronology of Proscribed and Prescribed Art* (Metuchen, N.J., 1972), reveals the extent of such acts, worldwide, from antiquity to the late twentieth century. See also D. Freedberg, "The Senses and Censorship," chapter 13 in *The Power of Images: Studies in the History and Theory of Response* (Chicago, 1989), pp. 345–377.

109 Illustrated before restoration in B. B. Fredericksen, *Masterpieces of Painting in the J. Paul Getty Museum* (Malibu, 1980), no. 26.

110 L. Steinberg, *The Sexuality of Christ in Renaissance Art and in Modern Oblivion* (New York, 1983), pp. 14–15.

111 L. Murray, *Michelangelo: His Life, Work, and Times* (London, 1984), p 162. Aretino's critical reaction was in part provoked by Michelangelo's having ignored his requests for some drawings.

112 Ibid., pp. 161–167, and P. de Vecchi, "Michelangelo's Last Judgment," in *The Sistine Chapel: The Art, the History, and the Restoration*, ed. C. Pietrangeli et al. (New York, 1986), pp. 190–197. For a copy of the

fresco in its original state painted in 1549 by Marcello Venusti (Naples, Capodimonte), see P. de Vecchi, *Michelangelo,* trans. A. Campbell (London, 1992), p. 122 (in color).

113 K. Brandt, "Initial Inklings of Michelangelo's Last Judgment," Paper presented at the College Art Association Annual Conference, Seattle, 1993. See also R. Cembalest and K. Shulman, "Leaving the Loincloths," *Art News* 91 (Summer 1992), p. 52, and J. Rockwell, "2nd Michelangelo Work Is Due for Unveiling," *New York Times,* March 20, 1994, sect. 5, p. 3.

114 Popham (note 87), vol. 1, p. 108, no. 254; vol. 2, pl. 370. The area where Mars and Venus were represented has been painted over in pink body color.

115 See L. Dunand, "Les estampes dites 'découvertes' et 'couvertes'," *Gazette des Beaux-Arts* 69 (April 1967), pp. 225–238 (for numerous other examples of such reworkings).

116 W. Kendrick, *The Secret Museum: Pornography in Modern Culture* (New York, 1987), p. 6 (citing Richard Payne Knight, *Discourse on the Worship of Priapus and Its Connection with the Mystic Theology of the Ancients* [1786]).

117 Ibid., p. 6.

118 Ibid., p. 16 (quoting M. L. Barré, *Herculanum et Pompéi, recueil général des peintures, bronzes, mosaïques, etc. . . .* , vol. 8, p. 12).

119 See, for example, Kendrick (note 116), pp. 7–10 (on the early catalogues of Pompeian artifacts).

120 See, for example, C. Johns, *Sex or Symbol? Erotic Images of Greece and Rome* (London, 1982). Johns (pp. 9, 29–32), discusses the Museum Secretum and the damage to scholarship caused by the segregation of "obscene" objects. She writes (p. 30), "'Obscenity' is not a scholarly category, it is a moral one, and it is academically indefensible."

121 J. Kardon, *Robert Mapplethorpe: The Perfect Moment,* exh. cat. (Philadelphia, The Institute, 1988). See C. S. Vance, "Issues and Commentary: The War on Culture," *Art in America* 77 (September 1989), pp. 39–43, and H. Kramer, "Is Art Above the Laws of Decency?" *New York Times,* July 2, 1989, sect. 2, pp. 1, 7.

122 J. Merkel, "Report from Cincinnati: Art on Trial," *Art in America* 78 (December 1990), pp. 41–49, and R. Cembalest, "The Obscenity Trial: How They Voted to Acquit," *Art News* 89 (December 1990), pp. 136–141. See also D. Barrie, "The Scene of the Crime" [Keynote address at the Seventy-ninth Annual Convention of the College Art Association, Washington, D.C.], *Art Journal* 50 (Fall 1991), pp. 29–32.

123 See Lowenthal (note 2), pp. 93–94, A-14.

124 Oil on copper, 21.2 × 30.5 cm (8¼ × 12 in.). New York, The Metropolitan Museum of Art (1993.333).

SELECTED BIBLIOGRAPHY

ANDREWS, K. *Adam Elsheimer: Paintings, Drawings, Prints.* New York, 1977.

ANZELEWSKI, F. *Dürer and His Time.* Exh. cat. National Gallery of Art, Washington, D.C., 1967.

BARRIE, D. "The Scene of the Crime" [Keynote address at the Seventy-ninth Annual Convention of the College Art Association, Washington, D. C.]. *Art Journal* 50 (Fall 1991), pp. 29–32.

BEGOEN, R., and J. CLOTTES. "Un cas d'erotisme prehistorique." *La Recherche* 15, 157 (July–August 1984), pp. 992–995.

BROOS, B. *Meesterwerken in het Mauritshuis.* Exh. cat. Mauritshuis, The Hague, 1987.

BROOS, B., and R. VAN LEEUWEN. *Twee decennia Mauritshuis: Ter herinnering aan Hans R. Hoetink, directeur 1972–1991.* Zwolle, 1991.

BROWN, B. L., and A. K. WHEELOCK, JR. *Masterworks from Munich: Sixteenth- to Eighteenth-Century Paintings from the Alte Pinakothek.* Exh. cat. National Gallery of Art, Washington, D.C., 1988.

BROWN, J. *Velázquez, Painter and Courtier.* New Haven, Conn., 1986.

BRUNE, J. de. *Emblemata of sinne-werck.* Amsterdam, 1624.

CATS, J. *Alle de wercken.* Amsterdam, 1665.

CEMBALEST, R. "The Obscenity Trial: How They Voted to Acquit." *Art News* 89 (December 1990), pp. 136–141.

CEMBALEST, R., and K. SHULMAN. "Leaving the Loincloths." *Art News* 91 (Summer 1992), p. 52.

CIERI, M., et al., eds. *Honoré Daumier: Histoire ancienne.* Exh. cat. J. Paul Getty Museum, Malibu, 1975.

CLAPP, J. *Art Censorship: A Chronology of Proscribed and Prescribed Art.* Metuchen, N.J., 1972.

COORNHERT, D. V. *Zedekunst, dat is, wellevenskunste.* Edited by B. Becker. Leiden, 1942 (based on 1586 edition).

CUMONT, F. *Recherches sur le symbolisme funéraire des Romains.* 1942. Reprint. New York, 1975.

DEURSEN, A. T. VAN. *Plain Lives in a Golden Age: Popular Culture, Religion, and Society in Seventeenth-Century Holland.* Translated by M. Ultee. Cambridge, 1991.

DUNAND, L. "Les estampes dites 'découvertes' et 'couvertes'," *Gazette des Beaux-Arts* 69 (April 1967), pp. 225–238.

FREEDBERG, D. *The Power of Images: Studies in the History and Theory of Response.* Chicago, 1989.

FREEDBERG, S. J. *Painting in Italy, 1500 to 1600.* Pelican History of Art. Baltimore, 1971.

FREDERICKSEN, B. B. *Masterpieces of Painting in the J. Paul Getty Museum.* Malibu, 1980.

———. *Masterpieces of Painting in the J. Paul Getty Museum.* Rev. ed. Malibu, 1988.

GAMBER, O. "Armour Made in the Royal Workshops at Greenwich: Style and Construction." *The Scottish Art Review* 12, 2 (1969), pp. 1–13, 30.

GOEDDE, L. O. *Tempest and Shipwreck in Dutch and Flemish Art: Convention, Rhetoric, and Interpretation.* University Park, Pa., 1989.

GROSSHANS, R. *Maerten van Heemskerck: Die Gemälde.* Berlin, 1980.

HACKENBROCH, Y. *Renaissance Jewellery.* London, 1979.

HARRIS, E. *Velazquez.* Oxford, 1982.

HINDMAN, S. L. *Christine de Pizan's "Epistre d'Othéa": Painting and Politics at the Court of Charles VI.* Toronto, 1986.

HOMER. *The Odyssey of Homer.* Translated by R. Lattimore. New York, 1967.

HULSIUS, B. *Emblemata sacra . . .* N.p., 1631.

HYMANS, H. *Près de 700 biographies d'artistes Belges.* Vol. 2 of *Oeuvres de Henri Hymans.* Brussels, 1920.

The Illustrated Bartsch. Vol. 4, *Netherlandish Artists.* Edited by W. Strauss. New York, 1980.

INGAMELLS, J. *The Wallace Collection Catalogue of Pictures.* Vol. 3, *French before 1815.* London, 1989.

JENSEN, H. J. *The Muses' Concord: Literature, Music, and the Visual Arts in the Baroque Age.* Bloomington, Ind., 1976.

JERVIS, S. *Printed Furniture Designs before 1650.* [London,] 1974.

JOHNS, C. *Sex or Symbol? Erotic Images of Greece and Rome.* London, 1982.

JONGH, E. DE. *Portretten van echt en trouw: Huwelijk en gezin in de Nederlandse kunst van de zeventiende eeuw.* Exh. cat. Frans Halsmuseum, Haarlem, 1986.

————— et al. *Tot lering en vermaak.* Exh. cat. Rijksmuseum, Amsterdam, 1976.

KARDON, J. *Robert Mapplethorpe: The Perfect Moment.* Exh. cat. The Institute, Philadelphia, Pa.(and other venues), 1988

KAUFMANN, T. D. "Eros et poesia: la peinture à la cour de Rodolphe II," *Revue de l'Art* 69 (1985), pp. 29–46.

KENDRICK, W. *The Secret Museum: Pornography in Modern Culture.* New York, 1987.

KRAMER, H. "Is Art Above the Laws of Decency?" *New York Times,* July 2, 1989, sect. 2, pp. 1, 7.

LARSSON, L. O. "Bildhauerkunst und Plastik am Hofe Kaiser Rudolfs II." *Leids Kunsthistorisch Jaarboek* (1982), pp. 211–235.

Lexicon Iconographicum Mythologiae Classicae (LIMC). Vol. 2, pt. 1. Munich, 1984.

LINDEMAN, C. M. A. A. *Joachim Anthonisz. Wtewael.* Utrecht, 1929.

LORD, C. G. "Some Ovidian Themes in Italian Renaissance Art." Ph.D. diss., Columbia University, 1968.

LOWENTHAL, A. W. *Joachim Wtewael and Dutch Mannerism.* Doornspijk, 1986.

—————. "The Disgracers: Four Sinners in One Act." In *Essays in Northern European Art Presented to Egbert Haverkamp-Begemann on His Sixtieth Birthday.* Doornspijk, 1983.

—————. "Lot and His Daughters as Moral Dilemma." In *The Age of Rembrandt: Studies in Seventeenth-Century Dutch Painting.* Papers in Art History from The Pennsylvania State University 3. N.p., 1988.

—————. *Netherlandish Mannerism in British Collections.* Exh. cat. Entwistle Gallery, London, 1990.

—————. "The Paintings of Joachim Anthonisz. Wtewael (1566–1638)." Ph.D. diss., Columbia University, 1975.

LUIJTEN, G. et al., eds. *Dawn of the Golden Age: Northern Netherlandish Art 1580–1620.* Exh. cat. Rijksmuseum, Amsterdam, 1993.

MANDER, C. VAN. *Dutch and Flemish Painters: Translation from the Schilderboeck.* Translated by C. van de Wall. 1936. Reprint. New York, 1969.

—————. *Het Schilder-Boeck.* Haarlem, 1604.

—————. *Karel van Mander, Den grondt der edel vry schilder-const.* Translation and commentary by H. Miedema. 2 vols. Utrecht, 1973.

MERKEL, J. "Report from Cincinnati: Art on Trial." *Art in America* 78 (December 1990), pp. 41–51.

MURRAY, L. *Michelangelo: His Life, Work, and Times.* London, 1984.

OVID. *The Art of Love, and Other Poems* [Ars amatoria]. Translated by J. H. Mozley. Vol. 2 of *Ovid in Six Volumes.* 2nd ed., rev. The Loeb Classical Library. Cambridge, 1979.

————. *Metamorphoses.* Translated by F. J. Miller. Vols. 3 and 4 of *Ovid in Six Volumes.* 3rd ed., rev. The Loeb Classical Library. Cambridge, 1977.

PANOFSKY, E. *Studies in Iconology: Humanistic Themes in the Art of the Renaissance.* Oxford, 1939.

PINDAR. *The Odes of Pindar.* Translated by Sir J. Sandys. The Loeb Classical Library. Cambridge, 1978.

PISAN, C. de. *The Epistle of Othea to Hector or The Boke of Knyghthode.* Translated by S. Scrope. London, 1904.

POPHAM, A. E. *Catalogue of the Drawings of Parmigianino.* 3 vols. New Haven, Conn., 1971.

POST, L. A. "The Pattern of Success: Homer's Odyssey." In *From Homer to Menander: Forces in Greek Poetic Fiction.* Berkeley, 1951.

PROWN, J. D., and P. WALCH. "A Note on Copley's *Forge of Vulcan.*" *The Art Quarterly* 33, 2 (1970), pp. 176–178.

RATCLIFF, C. "Not for Repro." *Artforum* (February 1992), pp. 82–85.

RAY, J. *Observations . . . in a Journey through . . . the Low Countries.* London, 1673.

REID, J. D. *The Oxford Guide to Classical Mythology in the Arts, 1300–1900s.* 2 vols. New York, 1993.

REZNICEK, E. K. J. *Die Zeichnungen von Hendrick Goltzius.* Translated by I. Jost. 2 vols. Utrecht, 1961.

ROBERT, C. *Die antiken Sarkophag-Reliefs,* vol. 3, pt. 2. Berlin, 1904.

ROCKWELL, J. "2nd Michelangelo Work Is Due for Unveiling." *New York Times,* March 20, 1994, sect. 5, p. 3.

SCHAMA, S. *The Embarrassment of Riches: An Interpretation of Dutch Culture in the Golden Age.* New York, 1987.

SCHENKEVELD, M. A. *Dutch Literature in the Age of Rembrandt: Themes and Ideas.* Philadelphia, 1991.

SEGAL, S. *A Fruitful Past: A Survey of the Fruit Still Lifes of the Northern and Southern Netherlands from Brueghel till Van Gogh.* Exh. cat. Gallery P. de Boer, Amsterdam, and Herzog Anton Ulrich-Museum, Braunschweig, 1983.

————. *A Prosperous Past: The Sumptuous Still Life in The Netherlands, 1600–1700.* Edited by W. B. Jordan. Exh. cat., Stedelijk Museum Het Prinsenhof, Delft; Fogg Art Museum, Harvard University, Cambridge; and Kimbell Art Museum, Fort Worth, Texas, 1988.

SICHTERMANN, H., and G. KOCH. *Griechische Mythen auf römischen Sarkophagen.* Bilderhefte des Deutschen Archäologischen Instituts Rom 5/6. Tübingen, 1975.

SLUIJTER, E. J. "Venus, Visus en Pictura." In *Goltzius-Studies: Hendrick Goltzius (1558–1617). Nederlands Kunsthistorisch Jaarboek* 42–43 (1991–1992). Zwolle, 1993.

SMITH, D. R. *Masks of Wedlock: Seventeenth-Century Dutch Marriage Portraiture.* Ann Arbor, Mich., 1982.

SOKOLOVA, I. "A New Acquisition by the Hermitage Museum: Joachim Wtewael's *Lot and His Daughters.*" *Burlington Magazine* 133 (September 1991), pp. 619–622.

A Story of Shears and Scissors, Their Origin and Growth in the Old World and the New . . . [Newark, N.J.,] 1948.

STEINBERG, L. *The Sexuality of Christ in Renaissance Art and in Modern Oblivion.* New York, 1983.

STRAUSS, W. L., ed. *Hendrik Goltzius, 1558–1617: The Complete Engravings and Woodcuts.* 2 vols. New York, 1977.

SYME, R. *History in Ovid.* Oxford, 1978.

THIEL, P. J. J. VAN. "Cornelis Cornelisz van Haarlem as a Draughtsman." *Master Drawings* 3, 2 (1965), pp. 123–154.

VANCE, C. S. "Issues and Commentary: The War on Culture." *Art in America* 77 (September 1989), pp. 39–43.

VECCHI, P. *Michelangelo.* Translated by A. Campbell. London, 1992.

————. "Michelangelo's Last Judgment." In *The Sistine Chapel: The Art, the History, and the Restoration.* Edited by C. Pietrangeli et al. New York, 1986.

VELDMAN, I. M. *Maarten van Heemskerck and Dutch Humanism in the Sixteenth Century.* Translated by M. Hoyle. Maarssen, 1977.

VRIES, P. VREDEMAN DE. *Verscheyden Schrynwerck.* Amsterdam, 1630.

WINCKELMANN, J. *Monumenti antichi inediti . . .* 2nd ed. 3 vols. Rome, 1821.

WIND, E. *Pagan Mysteries in the Renaissance.* London, 1958.

ACKNOWLEDGMENTS

This book is in your hands thanks to Andrea P. A. Belloli's interest in having Wtewael's *Mars and Venus Surprised by Vulcan* represented in the Getty Museum Studies on Art series, for which she was the original editor. I am grateful to her for instigating my return to the issues surrounding that ever-challenging artist, and especially for occasioning my extended look at the J. Paul Getty Museum's extraordinary painting. Other staff members at the Museum have been generous with support of various kinds: Dawson Carr, Associate Curator of Paintings; Peter Fusco, Curator of Sculpture and Works of Art; Mark Greenberg, Managing Editor; John Harris, Editor; Lee Hendrix, Associate Curator of Drawings; Christopher Hudson, Publisher; Thomas Kren, Curator of Manuscripts; Mark Leonard, Conservator; Andrea Rothe, Conservator-in-Charge; and John Walsh, Director. I thank them all for sharing their ideas and enthusiasm for this project.

I have turned for help to museum staff elsewhere as well, and they, too, have been unstinting with expertise and assistance. Thanks go especially to Judith M. Henff and Carolyn Sargentson in the Department of Furniture at the Victoria and Albert Museum; and to Donald J. LaRocca, Assistant Curator of Arms and Armor; Marica Vilcek, Associate Curator in Charge, Catalogue Department; and Elizabeth Wyckoff, Curatorial Assistant, Prints and Illustrated Books, at the Metropolitan Museum of Art, New York. Marion Burleigh-Motley, Education Division, Walter Liedtke, Curator of European Painting, and the staff of the Watson Library at the Metropolitan Museum also offered invaluable help.

Johan C. Bosch van Rosenthal, of the Old Master Drawing department at Christie's Amsterdam, was also generous with time and support.

I gratefully acknowledge the importance of talks with Ann Jensen Adams, Elizabeth Bartman, Egbert Haverkamp-Begemann, Judith Bernstock, Roberta Entwistle, and Ilja M. Veldman, which sharpened my thinking on crucial points. The manuscript benefitted from the constructive criticism of Rhonda Baer, Lee Hendrix, Lawrence Nichols, and Lisa Vergara, to all of whom I also offer warm thanks. Finally, I am indebted to my editor, Cynthia Newman Bohn, who wielded her blue pencil with a discerning eye and a keen mind.

AWL

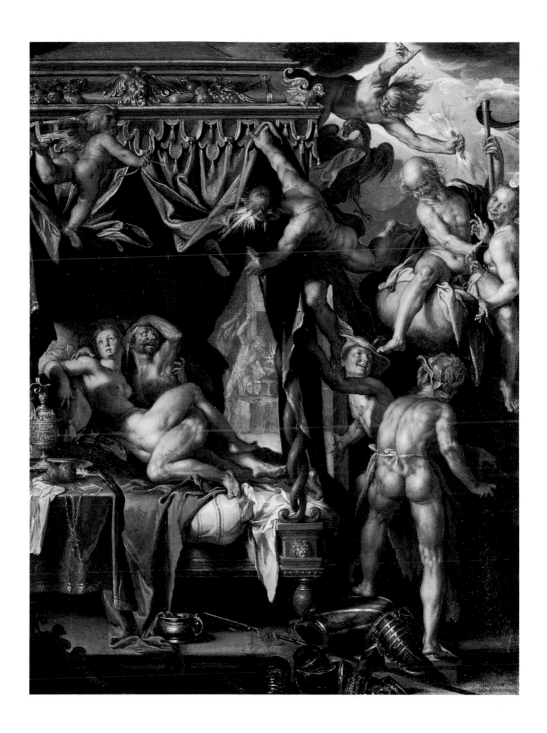

Foldout
Joachim Wtewael
(Dutch, 1566–1638).
*Mars and Venus
Surprised by Vulcan,*
circa 1606–1610.
Oil on copper, 20.25 x
15.5 cm (8 x 6⅛ in.).
Malibu, J. Paul Getty
Museum (83.PC.274).